Digital
photography
tricks of the trade

Digital **photography** tricks of the trade

Tim Gartside

David and Charles

For Yvonne, with all my love

A DAVID & CHARLES BOOK
David & Charles is a subsidiary of F+W (UK) Ltd.,
an F+W Publications Inc. company

First published in the UK in 2005

Distributed in North America
by F+W Publications, Inc.
4700 East Galbraith Road
Cincinnati, OH 45236
1-800-289-0963

A catalogue record for this book is available from
the British Library.

ISBN 0 7153 2157 9

Printed in Singapore by KHL Printing Co Pte Ltd
for David & Charles
Brunel House Newton Abbot Devon

Commissioning Editor Neil Baber
Desk Editor Ame Verso
Project Editor Ian Kearey
Art Editor Mike Moule
Designed by Think Tank Productions
Production Controller Kelly Smith

Visit our website at
www.davidandcharles.co.uk

David & Charles books are available from all good
bookshops; alternatively you can contact our Orderline
on (0)1626 334555 or write to us at FREEPOST EX2 110,
David & Charles Direct, Newton Abbot, TQ12 4ZZ
(no stamp required UK mainland).

AUTHOR'S ACKNOWLEDGMENTS
Sincere thanks are due to Canon, Pentax, Sigma,
Johnsons Photopia (Sekonic, Mamiya and Lastolite),
Nikon, Epson and Minolta and all other manufacturers
for use of their pictures in this book.
 A special thank you also to Dominic Crinson for his
beautiful ceramic and wallpaper designs on pages 156–7.
You can see more of his stunning work at www.digitile.
co.uk or www.crinson.com
 Thanks also to Neil Baber, Ame Verso and Mike Moule
at David & Charles for their hard work and input into
this project. Finally thanks to Jake Ferguson and Sarah
Underhill at Think Tank Productions.

Contents

Introduction

I have been interested in taking photographs since I first sequestered my father's camera while on holiday, taking over as the official holiday snapper. I finally got my hands on my very own camera, an Olympus OM10, when I was 18 years old, and from then on the bug became stronger and stronger: I spent the best part of the next 15 years learning and refining how to shoot using film and how to print images in a smelly darkroom full of chemicals.

It was while I was working for a reprographics company in London that I saw the enormous potential of a state-of-the-art computer system – you could remove the spots from a Dalmatian or turn them pink in minutes, not hours or even days. It would be over a decade before the cost of a computer system descended from the stratosphere to allow individual photographers the means to enter the digital world with a desktop computer system. Suddenly there was the capability to create images that we could

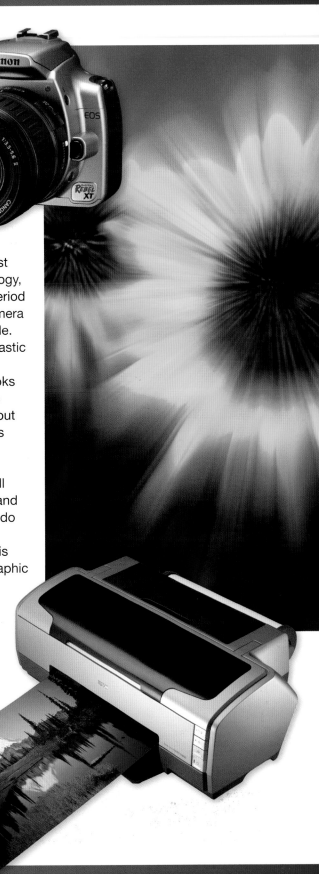

only have dreamed about using a conventional darkroom. This in turn opened up endless possibilities that were limited only by our imaginations.

In the early days, when I bought my Apple 9500 computer, a digital camera was a poor cousin to a film camera, so I had my film scanned using the Kodak Photo CD system. A quality film scanner still cost thousands then, but eventually, as with all new technology, the cost dropped to become reasonable. During this period digital cameras also blossomed, and a high-quality camera capable of stunning results is now fairly easily affordable.

Shooting digitally doesn't automatically give you fantastic pictures; just like getting your film prints back from the photo lab and thinking the sunset was better than it looks in your print, you can still end up disappointed with the results. Good photography still needs your personal input to get the most from your photographs. The good news is that you don't have to pay for expensive handmade prints at a lab because you can do it all yourself – and this is where this book will come in handy. It explains all the basics to give your photographs an instant boost, and continues in greater depth, showing you what you can do once you have mastered the basics.

The learning curve can be steep to begin with, but it is well worth the effort, as you can improve your photographic abilities and confidence immensely once you begin to master the software, and eventually you will be able to produce images that look truly professional. The instant viewing of a digital image, using the built-in screen on a digital camera, gives you the confidence and knowledge to tackle even the most complex photographic situations with ease. Whether you want to print, frame or e-mail your photographs, you can learn both how to take great images and how to make the most of them using your computer.

Tim Gartside

Cameras

Not many years ago, a digital camera with a 1.3-megapixel sensor would have cost the same as a new mid-range car. Today a 4-megapixel camera will set you back only a fraction of that amount. Digital cameras and computers have come a long way in the past few years. Even some of the most basic cameras can now produce good-quality results. As well as improving quality by increasing the pixel count, the manufacturers have also started to drop their prices.

Once the domain of professionals, digital SLRs (Single Lens Reflex) are now at their most affordable prices ever, with the currently most reasonably priced kits available from Canon and Nikon. There has never been a better time to buy a digital camera, as prices and quality are now comparable to those of traditional film cameras. The quality of 5- or 6-megapixel cameras is now so good that you can rely on them to give you top-quality results for years to come, without worrying whether the next model may be better, cheaper and faster.

There is a bewildering number of different cameras to choose from, and your camera choice will ultimately be based on the types of photographs that you want to create.

Entry-level cameras

These cameras are designed for those who use a camera only now and again for a special occasion, such as a birthday or wedding. They have replaced the single-use throwaway or small compact camera; they generally offer around 2–3 megapixels and usually have a fixed lens and limited features.

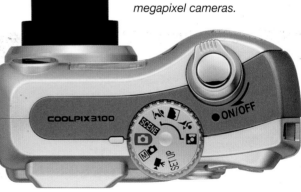

▼ *Enthusiast-level camera*
A4-size (21x29.7cm/8¼x11¾in) prints are possible from 3–4 megapixel cameras.

◀ *Compact entry-level camera*
A 2-megapixel camera will produce prints up to a size of only 7x5in before losing quality.

Enthusiast-level cameras

These cameras are aimed at those who want a little more versatility and control over their images. Usually with 3–5 megapixels, they often have a limited zoom lens so you can frame your pictures more easily.

Prosumer cameras

These cameras are aimed at the consumer who wants professional-quality results without the expense or complexity of a digital SLR. The latest models start at 4 megapixels and rise to 8 megapixels. Be careful about paying for more pixels than you need: a 5- or 6-megapixel camera can produce prints up to A3 size (29.7x42cm/11¾x16½in) with ease. If you don't need bigger prints than this on a regular basis, the extra pixels may be wasted and you should consider performance, price and flexibility above the number of pixels.

Prosumer cameras often have a technical specification equal to that of a digital SLR; the main difference is that you get a fixed zoom lens that cannot be changed, and a more compact body. There will be numerous metering modes as well as the more basic scene modes, electronic viewfinders, state of the art electronics and CCDs (Charge-Coupled Devices).

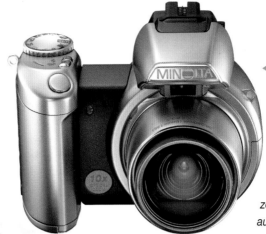

◀ *Prosumer camera*
This offers an excellent range of features, including top-quality lenses, and has a good zoom range and auto-focus abilities.

Digital SLRs

If you are serious about your photography or already have a film SLR, your best choice is a professional digital SLR, which is exactly the same as a traditional film SLR but with a CCD sensor instead of a film back. If you already own a camera system with interchangeable lenses, it makes sense to utilize these lenses on a new digital camera.

These cameras offer the very best in image quality, handling and versatility. They offer the best quality: 6 megapixels is the norm, going up to 16 megapixels on some full-frame cameras. They allow pictures to be captured in TIFF or RAW formats as well as JPEG (see File formats, page 36). In addition, they offer a wider range of shutter speeds and colour settings.

The main benefit of using a digital SLR has to be the ability to change lenses (see Lenses, page 12). Although two zooms, for example a 20–40mm and an 80–300mm, cover many shooting situations, you can also buy specialist lenses. If you are a keen landscape photographer, you may want a wide-angle lens, such as a 12–24mm, for capturing wide, open vistas; for close-up work you can buy a dedicated macro lens; and if you like sports or wildlife photography, you have the option to use a long, fast, telephoto lens, such as a 300mm f2.8 or 400mm f2.8.

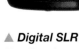

▲ *Digital SLR*
Excellent lens choice, fast start-up times, zero shutter lag, fast write speeds, bright and accurate viewfinders and an impressive array of exposure modes and user settings make digital SLRs the top choice for high-quality photography.

Resolution, megapixels and sensors

One of the most important things to consider when choosing a camera is resolution, measured in megapixels: 1 megapixel is equivalent to 1,000,000 pixels on a CCD sensor, so a 5-megapixel camera has 5,000,000 pixels with which to capture information. A CCD (Charge-Coupled Device) or CMOS (Complementary Metal Oxide Semiconductor) image sensor is at the heart of most digital cameras; this is a chip made up of millions of light-sensitive sensor elements, each equivalent to one pixel, so the more pixels you have, the better the image quality will be. Most sensors are smaller than the size of a traditional 35mm slide, due to the cost of manufacture; some cameras have a full-frame sensor, but these are very expensive indeed.

Optical zoom vs digital zoom

Many compact cameras cheat by making their zooms seem bigger than they actually are. You may see two figures, one stating optical zoom at 4x, say, and another figure giving

▲ *Controls*
The controls on most digital cameras above entry level are identical to those on film SLRs, with the addition of digital information.

Digital memory

Once the sensor has captured the image, it is saved to a removable memory card so another shot can be taken. Professional digital SLRs have large internal memory buffers that allow you to shoot many frames per second using the built-in motor drive before needing to save the images to a card; this can be important if you want to capture many shots of fast-moving objects in sports or wildlife photography. The cameras also transfer the data very quickly, giving you the freedom to keep on shooting.

There are numerous card designs on the market, the most popular of which is the CompactFlash system; others include Memory Stick, Smart Media, Secure Digital, Multimedia, FinePix and XD. CompactFlash cards are available from 32MB up to 4GB, although this looks set to rise in the near future. You can also buy an IBM Microdrive, which uses a tiny hard drive like the one used in your computer, and is available in sizes from 1–4GB.

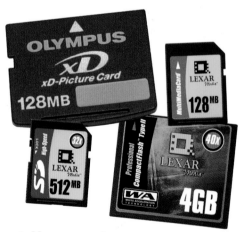

▲ *Memory cards*
Just part of the great variety of cards used by digital cameras, those shown here are among the most commonly used.

digital zoom at 5x. Digital zooming is done by software interpolation, not by the lens magnifying the image – this is like taking a 10x8in image and cropping out the centre to create a 6x4in image, then enlarging it back up to 10x8in: quality will be lost. Always go by the camera's optical zoom figure and treat the digital zoom as a gimmick.

Keeping your camera sensor clean

Fixed-lens camera designs are not affected by dust, as the lens unit is permanently sealed to the camera body. Digital SLRs can suffer from dust getting on to the delicate low pass filter, a protective filter on top of the sensor.

Always change lenses carefully to avoid dust entering the camera. Never leave the camera open, and always have a lens or body cap in place when it is not in use. Visually check the sensor by flipping the mirror up using a long exposure or the 'B' setting, where the mirror will stay up until you release the button. Check your instruction book for other methods. Gently blow away dust using a brushless blower – bristles can damage the filter – or you can try spraying air from a pressurized can from about 30cm (12in) away.

However you choose to clean your camera, it is important to do so with great care; it is best to send the camera to an authorized dealer for cleaning if you are in any doubt.

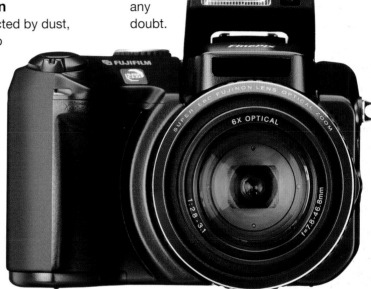

▲ *Size*

The revolution in digital cameras has been accompanied by a change in the traditional sizes available; both prosumer and SLR cameras are smaller and easier to hold than their film counterparts.

Card capacity
(numbers of shots are approximate averages)

	2MP	3MP	4MP	5MP	6MP
64MB	70	52	30	25	19
128MB	140	105	60	50	37
256MB	280	211	120	100	75
512MB	560	420	240	200	150

Lenses

Lenses control the focus, from close-up to infinity, and in older lens designs the aperture ring can also be adjusted from the lens. The close-focus ability is dependent on the lens design.

Most digital cameras come with a fixed lens that works as a 'jack of all trades'. These lenses are often very good, but if you want maximum flexibility you need a digital SLR that has interchangeable lenses.

The majority of fixed-lens cameras have a good telephoto range between 100–250mm, but fall down with worse wide-angle coverage; in some cases, a rather poor 35mm angle is all that is available. For serious landscape work you should have the ability to choose from 17mm up to 40mm. Portraiture is usually covered well in the 80–150mm range, and for serious sports and wildlife photography the range starts at 200mm and goes up to 800mm. Many modern lenses have good macro abilities, but you need to buy a specialist macro lens with a life-size 1:1 ratio for serious close-focus shots.

▲ *Changeable lens*
Most lenses can be swapped between film and digital SLRs of the same make.

Focal factor

The full-frame 35mm format is used here as the standard for describing a lens's focal length. All 35mm film cameras use this size, so it is easy to cross-reference between different manufacturers; digital cameras are more difficult, as there is no single standard CCD size.

Digital camera sensors range from full frame to quite small, so the size of the smaller sensors is a determining factor on the actual focal length of your lenses. Fixed-lens cameras are not affected by this as such, but care must be taken to choose a camera that has a zoom with a good range of focal lengths. Unlike full-frame sensor cameras, which don't alter the focal length but are prohibitively expensive for most people, a camera with a smaller sensor will increase the focal length of your lens by a factor of 1.5 or more (see table on page 14). A standard 28–80mm zoom, for example, in effect becomes a 42–120mm with a factor of 1.5. For this reason, recent lens designs have been created specifically for digital cameras. The widest zoom lens at the time of writing is the 12–24mm, which gives an angle of view equivalent to an 18–36mm lens on a 35mm camera.

◀ *Focal factors*
This shot demonstrates the potential loss of image when using a 28mm lens on a digital camera compared to a traditional full-frame model. With a focal factor increase of 1.5, the lens becomes 42mm, resulting in a 50 per cent loss of image. To counter this, ultra-wide-angle lenses have been designed; the only other way to resolve the situation is to stand further back, but this is not always possible.

Types of lenses

▼ Fish-eye (16mm or 8mm)

These remarkable optics allow a semicircular 180-degree angle of view with a 16mm lens; Nikon's 10.5mm fish-eye allows the full 180-degree angle of view to be fully realized with a digital SLR. An 8mm 360-degree fish-eye is available from Sigma.

Wide-angle (18–35mm) ▷

Most landscapes are shot within this focal length range. Wide-angle lenses allow you to get a huge amount of landscape into the shot, and also offer great depth of field, even at modest apertures such as f8. The angle of view can be over 120 degrees, which allows you to capture truly sweeping vistas. The latest wide-angle zooms of 12–24mm offer a digital focal length of around 18–36mm, which makes them ideal for landscape photography.

▼ Standard to short telephoto (40–135mm)

This focal length range is ideal for portraiture shots and candid photography. It brings the subject a little closer to you without the problem of camera shake encountered using longer focal lengths. A standard 50mm lens becomes a useful 80mm when fitted to a digital camera, and its fast apertures allow hand-held shots even in low-light conditions.

◀ Telephoto (150mm–400mm and beyond)

Some fixed-lens cameras can get up to 300mm, which becomes a whopping 450mm when you take the focal factor into account. Telephotos compress the image, so objects that are far apart look as though they are standing next to each other. This allows you to blur the background creatively so the subject becomes more prominent. A tripod is essential, as the slightest shake will cause blurred images. Some lenses and cameras are available with gyroscopic motors that help to combat camera shake, allowing an extra 2–3 stops of shooting speed.

Focal factor conversion chart

35mm	x1.5	x1.6	x1.8
10.5	16	16.8	18.9
17	25.5	27.2	30.6
20	30	32	36
24	36	38.4	43.2
28	42	44.8	50.4
35	52.5	56	63
50	75	80	90
60	90	96	108
85	127.5	136	153
100	150	160	180
150	225	240	270
200	300	320	360
300	450	480	540
400	600	640	720
500	750	800	900

▲ *Focal factor*
This table shows how digital sensor size changes lenses' effective focal lengths (see page 12).

Flare and vignetting

Wide-angle lenses are prone to flare or ghosting. Use a lens shade where possible, or put your hand between the sun and the lens, taking care not to get it in the frame. Flare can be subtle and cause low contrast; shade the lens while viewing to check for this.

Wide-angle lenses also suffer from vignetting, where the corners of the image darken. This may be due to one or more glass filters screwed into the front filter thread; some lens shades can also cause it. Use the new ultra-thin filter designs, or buy a plastic resin filter system that is capable of working with ultra-wide-angle lenses.

Hyperfocal focusing ▶
Using this technique, everything in the frame appears in sharp focus.

Focusing

All modern cameras use auto-focusing to help you capture sharp images, and most of the time this works really well. Top models also allow you to switch off the auto function to allow manual focusing, as the camera doesn't always know where you want to focus. For creative shots, for example, you may deliberately focus on the background to blur the foreground. Night and low-light photography can also fool focusing systems, as the contrast is often too dark for the system to latch on to a subject. Good systems allow you to get sharp pictures in difficult situations, such as when shooting fast cars or a person running.

Hyperfocal focus

This is a technique that is especially useful for landscapes, and relies on your lens having a depth-of-field scale. It is best done using manual focus.

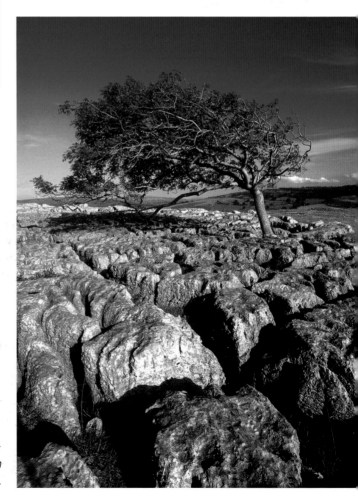

Set an aperture of, say, f16, and then turn the focus until the infinity (∞) symbol is over your chosen aperture. Everything from infinity to about 0.8m (2ft) will be in focus. If you leave the infinity setting at zero the closest focus will be at 1.8m (5ft). This can be critical if you want front-to-back sharpness. In practice, even without a depth-of-field scale, you can use the basic rule of focusing one-third of the way into a shot, which is where most subject matter is usually placed.

Differential focus

This technique deliberately creates a narrow depth of field to focus the attention on the subject. Use a large aperture, such as f1.8–f4, and get in close to your subject with a standard lens, or use a telephoto lens.

▼ *Differential focusing*
The narrow depth of field throws the foreground into sharp relief.

Depth of field

This is the zone of sharpness within an image and is controlled by the aperture and focal length of the lens. A wide-angle 20mm lens at f16 will allow front-to-back sharpness, whereas with a 400mm telephoto only a shallow area in front of and behind the subject will be in focus, even at f16. The wider the aperture, the shallower the depth of field. Moving in close to your subject with a macro lens also reduces the zone of sharpness and has a similar effect to that of a telephoto, as both are magnifying the subject.

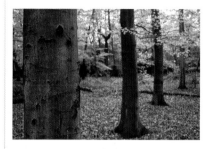

◀ *The lens was focused on the nearest trunk for all shots. At the widest aperture of f3.3 there is a marked fall-off in depth of field beyond the nearest trunk. The background is out of focus.*

▶ *At f5.6 the background is still soft, but you can already see an improvement in sharpness.*

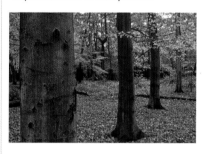

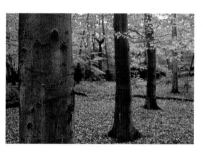

◀ *At f8 improvement continues and there is an acceptable sharpness across most of the image. This aperture is a good compromise between speed and depth of field.*

▶ *At f11 there is a major improvement in depth of field and the image is sharp from front to back. Shutter speeds begin to get slow in all but the brightest light, and best quality is achieved with an aperture of f11 or smaller when using a tripod.*

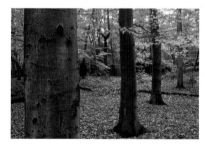

◀ *At f16 the quality only marginally improves, and you would need to view a large print to see any benefit from shooting at this aperture. Use f16 or f22 with medium-to-long telephotos and when shooting in macro mode if you want to maximize depth of field for magnified subjects.*

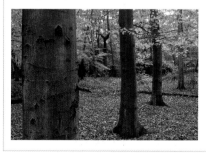

Accessories

It is a very good idea to spend some time choosing the right camera and lenses, but it is easy to neglect the bits and pieces that you should take with you when you go out on your travels. Some accessories are luxuries, but many are essential and help you get the most from your camera.

Camera bag

Get a bag that suits your requirements, or even two different bags that are likely to be suitable for different kinds of trip. Use a small bag for short trips where you don't want to be bogged down with heavy equipment; this should carry a camera, several lenses, filters, batteries and a bottle of water. A large backpack-style bag can carry much more gear in its numerous compartments. Make sure this has a waterproof hood and straps to spread the weight across your shoulders and chest, allowing you to carry more equipment over greater distances.

Tripod

A tripod is essential for getting pin-sharp pictures; if you are serious about photography, you must invest in one. A lightweight tripod is best for general use; if you buy a heavy tripod, you may end up leaving it at home. Carbon-fibre tripods give good height and are lightweight, but they are expensive.

Filters

A polarizer, several grey grads and a soft-focus filter are essential and will improve your photos greatly if you use them properly. Purchase a system that will fit all your lenses, such as the Cokin or Lee Filter square systems. Filters are discussed in more detail on page 18.

Useful extras

A **cable release** helps to keep camera vibration to a minimum, especially when using telephoto lenses. If your camera doesn't have a thread for a traditional cable release you will need an electronic remote control shutter release.

Spare batteries are a must – the day you are without them is the day you need them. Batteries are at their most vulnerable in cold weather, when the power drains from them more quickly.

A **small folding reflector** allows you to add reflected fill light into small objects. You can use sheets of silver and gold card folded up; the creases and tears actually add to the texture and pattern of the reflected light, although you can buy larger purpose-made folding reflectors.

Carry a **torch**, especially for night photography, to check camera settings, change lenses and for where there are no streetlights.

When shooting long exposures on the 'B' setting, use a **small black card** to cover the lens during the exposure, for instance to stop the exposure between firework explosions so you can capture several in one shot, or to stop something ruining the exposure, such as streaks of light from bus windows moving across the frame.

A **spirit level** that fits on a hot shoe ensures that horizons are not wonky.

Slanting horizons can be corrected later in an image-editing program, but it's better to get things right in-camera. Some tripod heads have a spirit level built in, but these are more costly.

Be sure to use a **lens hood**: flare is a major factor in ruining shots, and correcting flare on the computer is very difficult as the effect can cause problems across the entire frame. You can also use your hand or a black card above the lens.

Use a **lens cloth** and **blower brush** to remove dust, dirt and greasy fingermarks from your equipment. Lens cleaning fluid is available, but breathing on the lens and then wiping it with a microweave cloth gives the best results. You can also use a **can of pressurized air** very carefully to clean the camera.

During winter months keep **gloves, scarf and woolly hat** in the car.

Digital accessories

Spare memory cards are a must if you are out all day and can't download your images. Buy the best you can afford, but you won't need the fastest cards unless your career depends on it. Buy cards of 256MB or more if possible, so you are not forever changing cards.

Mini hard drives with a card reader, usually in 20GB, 40GB or 60GB, have a screen for viewing images. These drives are battery-powered, so you can download a full memory card in the field. Alternatively, with the correct cables, you can use a car cigarette lighter as a DC power source. **CD writers** are also battery-powered and offer the greater security of writing to a safe, secure archive medium: if your hard drive fails, you lose everything; if a CD writer fails, you lose only the CD in the machine. Both systems are quite large and heavy, so aren't welcome companions on a long hike. Another option is an **Apple iPod**, which can hold digital images via a Belkin media reader.

A **memory card reader** is easier to use if you have several cards to transfer on to your computer. Readers are usually faster at transferring data and don't waste your camera's battery during the process.

A pressure-sensitive **graphics tablet**, such as the Wacom Intuos or Graphire series, works like a pen and is extremely versatile, natural and intuitive. It can improve your productivity and take your skills to a new level.

An **external hard drive** can be a big help if your computer's hard drive starts to overflow. Hard drives are quick and easy to attach, usually by Firewire or USB 2.0. Remember to back up on to CD/DVD at regular intervals.

A **Zip drive** using 250MB disks allows you to transfer files quickly from one computer to another. You can unplug the Firewire drive from one computer and plug it into the other without turning the computers off. The power supply also comes from the Firewire socket, so there are no power supply cables to mess with.

Why not try out a few **Photoshop plug-ins**? There are many on the market that create filter, frame, texture and masking effects. Check out Adobe's plug-in section on their website (www.adobe.com) for a complete list.

Graphics tablet ▶
In addition to feeling just like a pen, this is pressure-sensitive so you can create a wide range of paint effects by varying the pressure. You will never use your mouse again for digital retouching.

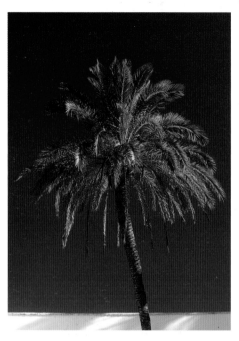

Filters

Filters are an inexpensive way of altering the images you take in-camera. Before the advent of digital photography, they were the only cheap way to manipulate your images. There are many gimmicky filters on the market, but the ones described below can help to transform your photography.

Using filters on a digital camera

Although some say you don't need to use any filters with a digital camera, 'we can always correct it later on the computer' is a lazy attitude. No software package can re-create the effect of a polarizer – it can only mimic it – and it is far better to get it right in-camera rather than leaving it all to the computer later on. Save your time on the computer for correcting difficult shots and more creative things, such as montages (see page 126).

UV/skylight filter

This filter doesn't change the image in any dramatic fashion. It absorbs UV rays, which can cause a blue, hazy tinge, especially at high altitude in mountains. Its main role is to protect the front element of your lens from scratching and dirt, both of which can lead to an expensive repair bill.

Polarizing filter

This is one of two must-have filters, the other being a grey graduate (see opposite). A polarizer's effect on the quality of your final shot can be breathtaking: it makes all colours brighter and more saturated. Blue skies benefit most – they can go from being rather insipid to a beautiful, dark, dramatic blue.

Polarizers come in two types; circular and linear. Circular polarizers are needed for most modern cameras with auto-focus systems and for cameras with semi-silvered mirrors.

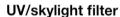
▲ Polarizing filter
The effect of a polarizing filter can be seen clearly in these pictures of a palm tree against a clear blue sky. When the polarizer is used (top) the colours of the scene are much more saturated and intense than without the polarizer in place (below).

> **Trade Tips: polarizers**
>
> 📷 For maximum effect use a polarizer at a 90-degree angle to the sun.
>
> 📷 Wide-angle lenses (28mm and wider) can cause vignetting, where black patches in the corner of the image are caused by having too many screw filters attached to the front lens. Temporarily remove any screw-type UV filters and use only the polarizer. Extreme wide-angles can vignette even with this, so use a slim filter. Manufacturers such as Lee and Cokin offer large square resin filters that can overcome this problem.
>
> 📷 Polarizers reduce the light that reaches your camera by up to 2 stops (1/60 sec becomes a shaky 1/15 sec) when fully polarized, so use a tripod in all but the brightest light conditions.

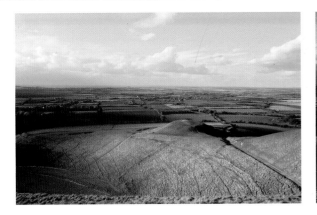

▲ Grey graduate filter
This simple filter allows you to balance the light levels in a landscape so that all detail is faithfully recorded as you saw it.

Trade Tips: grey grads

🎞 When shooting reflections in dark water, use a grey grad to cover everything except the water, otherwise you may find that the reflection and water become pitch black.

🎞 When placing the grad over the landscape, make sure it isn't wonky and take great care that the grey area covers all the sky and doesn't spill over into the land too much.

Soft-focus filter

Most photographers like to add a creative element to their shots, and a soft-focus filter is an obvious and easy way to achieve this. Soft-focus filters help to alter the mood of a shot and create a romantic, dreamy effect reminiscent of paintings, especially when used with a fast, grainy film. In portraiture this filter can help to remove wrinkles and harsh skin tones. The effect works best with a wide aperture. The smaller the aperture, the weaker the halo effect becomes. Use your depth-of-field button to gauge the final effect. You can also try overexposing to enhance the halo effect.

Soft-focus filter ▶
This reduces contrast and adds an ethereal glow to shots, especially if they are backlit by strong sunlight: dappled highlights flare to create a beautiful halo effect.

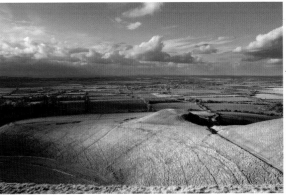

Grey graduate filter

This is the second most important filter you need, after the polarizer; in fact, you should have two or three grey grads with different densities. High contrast is a common problem with landscape shots, where the sky can be several stops brighter than the land. Without filtration you either lose the detail in the sky or the land becomes much too dark.

When exposing a scene, it is best to meter from the foreground first to give a correct exposure to the land. By placing the filter over the sky area, you automatically balance the two areas successfully. Which you use depends on the effect you are looking for: a darker filter gives a moodier, stormier feel to shots, especially if you combine a polarizer and light grey grad to achieve a dramatic effect. It is also possible to meter with the grad in place.

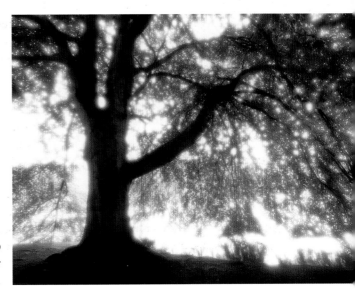

Exposure

Getting the correct exposure is fundamental to creating high-quality images. It is the relationship between the shutter speed and aperture at a given ISO (International Standards Organization) setting that determines correct exposure. An ideal exposure should capture as much detail as possible without underexposure (too dark) or overexposure (too light). Using the LCD screen on the back of your digital camera gives a much higher success rate than with a film camera, as you don't have to wait to develop your photos before seeing the results.

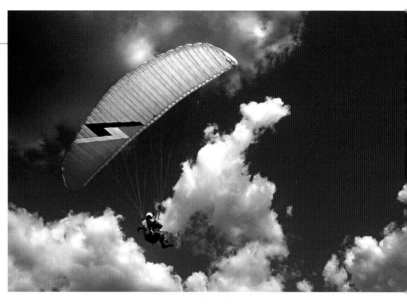

▲ *Freezing movement*
A telephoto lens and a shutter speed of 1/500 sec were used to freeze this glider in mid-air.

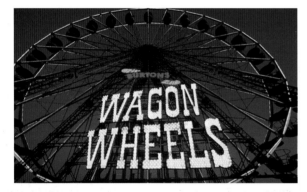

▲ *Capturing movement*
By increasing the shutter speed from 2 sec at f8 when the wheel was still (above) to 8 sec at f16 when it was moving (below), different effects have been created.

Shutter speed and aperture

Changing the shutter speed and aperture can radically alter a photograph. Long shutter speeds allow moving elements within the shot to blur for effect, while short, fast shutter speeds allow the subject to be frozen so that more detail can be seen. What you choose depends on the mood and style you want to convey: long shutter speeds give an ethereal mood, and fast speeds allow you to focus on a subject, bringing it into sharper focus and giving it more emphasis.

The shutter speed is the time it takes for the camera's shutter blind to lift and expose the CCD sensor to light. The aperture or iris/diaphragm is the system of blades in the lens that create a hole for the light to pass through. The size of the hole is given a known value called an f-stop. The larger the aperture (f1.8), the more light is let in, allowing a faster shutter speed at the expense of shallower depth of field. The smaller the aperture (f16), the greater the depth of field, but the shutter speed has to be slow to let the right amount of light fall on to the CCD. There is always a choice – speed or depth of field.

Most good cameras allow you to alter the shutter speed and aperture independently so

Aperture and shutter speed combinations for optimum exposure

f1.8	f2.8	f4	f5.6	f8	f11	f16	f22
1/1000 sec	1/500 sec	1/250 sec	1/125 sec	1/60 sec	1/30 sec	1/15 sec	1/8 sec

that more creative and accurate exposures can be made. Settings made between 30 sec and 1/8000 sec give long exposures for night shots or very fast exposures to freeze action. Some cameras also have a bulb or 'B' setting, where you can hold the shutter release button down for as long as you want. The correct exposure is the right combination of shutter speed and aperture, as illustrated in the table above. Once the right combination is found, you can alter both together to create different effects.

Working from the table, if your exposure meter reads 1/60 sec at f8 you can alter both to a higher shutter speed, say, 1/1000 sec at f1.8 to freeze a fast-moving car. Alternatively, for maximum depth of field in a landscape, choose 1/15 sec at f16. As long as both are moved together, you get a correct exposure. With an aperture of f16 and a shutter speed of 1/1000 sec you get underexposure by 6 stops, yielding a black image. Overexposure occurs if you use f1.8 and 1/15 sec. Most pictures within one stop of the optimum exposure give correct tonal values.

Bracketing

One major problem with exposure is knowing which area to expose for and the effect the exposure will have on different areas of the frame. This is why filters are used to balance the image (see page 18). Another technique, called bracketing, involves taking a series of exposures just above and below the 'correct' one. This can be done manually or via a custom exposure mode setting. Dial in the number of shots above and below and the spacing of the f-stops (eg +/- ½-stop increments). When you press the shutter, the camera automatically captures the sequence.

Adobe Elements/ Photoshop CS allows a finer control of contrast and brightness when working on the image, so don't worry if it doesn't look perfect on screen. If in doubt, save all bracketed versions so different bits can be used from each one to create one perfect image later. Bracketing uses up memory card space at an alarming rate, so learn from each shot you take to boost your success rate.

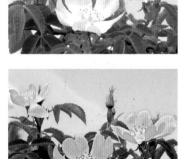

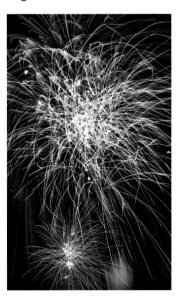

Recording ▶
multiple images
in the frame
Fireworks should be shot using a tripod and a long exposure of 5–30 sec. The longer the shutter speed, the more bursts are captured. Use the first bursts to compose the shot, and fit a zoom lens to alter the focal length quickly.

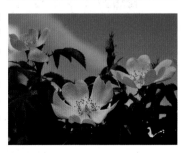

Bracketing exposures
In this bracketed sequence +1 stop overexposure (top), correct (centre) and -1 stop under- exposure (bottom) were used for the wild rose.

Exposure modes

Most cameras come with a variety of automatic and manual exposure modes. Switch to manual to take creative control.

P – auto multi-program

In this mode the camera adjusts both shutter speed and aperture to create a correct exposure. Turn the shutter speed dial to give a combination that suits you.

S (Tv) – shutter priority

Here you dial in your chosen shutter speed and the camera takes care of the aperture setting. Use this mode to set deliberately slow shutter speeds to blur moving objects such as water, or set fast shutter speeds to freeze the motion of moving objects.

A (Av) – aperture priority

This allows you to set the aperture of your choice while the camera automatically sets the shutter speed. Choose a small aperture of f16 to create maximum depth of field or a large aperture, such as f4, to blur the background in portraits.

M – manual

In this mode you have to dial in both aperture and shutter speed manually. Most cameras allow shutter speeds of 30–1/8000 sec. You can also choose the 'B' (Bulb) setting, which holds the shutter open until you release it – for when you want to use a very long exposure time. Correct exposure is determined by using the electronic analogue display in the viewfinder or a hand-held exposure meter. Generally, when the exposure bars are at 0, the exposure is correct for a midtone subject.

Metering modes

Many SLR cameras allow you to choose the best metering pattern for your subject.

Matrix

The matrix metering mode takes readings from up to 256 spots within the frame area. This generally gives a good exposure for general scenes, but the meter can be fooled if one area in the scene is significantly brighter or darker than the rest of the scene.

Centre-weighted

With centre-weighted metering, the whole scene is metered, but this time with an emphasis on the centre of the frame. Again, this system can be fooled in high-contrast situations and may need overriding manually.

Spot meter

A spot meter allows the precise measurement of your subject using a 3–8 per cent area in the middle of the meter's reference circle. You can alter the settings to allow the meter to take the reading from the focus area you have chosen. Although this is the most accurate method, you have to meter from tones that are equivalent to an 18 per cent grey midtone, such as dark grass or foliage. Use the camera's auto-exposure lock (AE-L) to take a reading and re-compose the shot, or dial in the settings manually.

Noise

To minimize noise – the grainy effect found on digital images, particularly those taken in low light – first set the ISO correctly. This can be increased from a normal fine setting of 100/200 to 1600 or more. Doubling the ISO from 200 to 400 gives an extra stop of shutter speed.

This extra speed becomes very useful when you are hand-holding the camera in low light conditions. If settings are 1/15 sec at f5.6 at ISO 200, this becomes a more useful 1/125 sec at f5.6 at ISO 1600.

In the same way as fast film, which suffers from increased grain, digital cameras suffer from increased noise when you increase the ISO. Modern cameras do a very good job of minimizing this problem, and may come with noise reduction (NR) software in the menu settings, which uses software to process the image after exposing it.

High and low key

The creative aspect of exposure control makes use of a more restricted tonal range. High-key portraits are bright and light in tone and deliberately overexposed to create a dreamy, soft effect, while low-key shots are often biased to dark tones to add extra mood and drama. High-key shots need a bright background and low-key shots need a dark background.

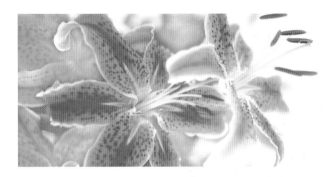

High key

The overall feel of a high-key image is bright; deliberate overexposure of the main subject by about 1 stop is used with a white or very light-toned background.

Traditionally the background is lit (if working in a studio) to blow out to white when exposed (several stops overexposed from the metered reading for the face), but it is possible to brighten the image in Photoshop or Elements using Levels. Using a soft-focus filter adds to the effect. Lighting the subject from the side or from below also enhances the high-key effect. Try to light the subject to create a soft, shadowless look – harsh black shadows will destroy the effect.

Aim to produce a print that is lighter than normal. Make a series of small rectangular test strips and see which one is the most pleasing before wasting expensive ink. Previously only black and white offered contrast control by using different grades of paper, but on a computer you can now alter the contrast of a shot quite easily.

▲ High-key lilies
These lilies were shot against a white background and deliberately overexposed to create a high-key effect, further enhanced by lightening the flower on the right.

Low key

This is the antithesis of high key, and the effect often produces dark, brooding images that create a feeling of mystery. It is often easy to create low-key shots in the landscape by placing the subject against a dark background. Light the subject to make the effect even more pronounced, as directional light automatically makes the background darker.

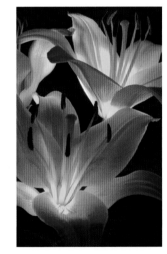

◀ Low-key lilies
This shot was taken using only a torch to light the flowers. The background wasn't lit by the torch, and so has gone naturally dark. The shutter was fired for 30 sec, and the torch was used to 'paint' light on to the flowers.

▲ Portraits
These shots show low-key (above) and high-key (below) effects used to enhance portraits.

Backlighting ▶
Set against a dark background, these backlit leaves provided the perfect natural low-key subject.

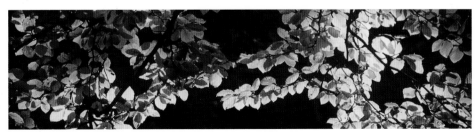

Composition

Composition, like most other things, can be tidied up later on the computer, but it is much more rewarding to get it right in-camera in the first place. Good composition is essentially an aesthetically pleasing arrangement of all the different elements within the frame of a photograph. It should bring order to a confusing scene and allow the viewer to understand what you were trying to photograph in the first place. The final choice of what is pleasing is the artist's, but knowing a few basic rules can make life easier in most situations.

Keep it simple
Don't try to cram lots of different elements into the frame, as they will just compete with each other for attention. Look at the frame edges for anything creeping into the composition. It's usually best to have just one main subject dominating the frame.

▼ *Foreground interest*
With a wide-angle lens it was possible to fill the foreground while keeping plenty of background detail to place the boats in their actual environment.

Foreground interest
This is especially important in landscapes shot with wide-angle lenses, which can sometimes look empty without the inclusion of a subject in the immediate foreground. This doesn't have to be the main subject matter, but it can help to lead the eye into the shot to where the subject is located. In a still life, this may well be the foreground, and the background is simply used to help place the subject within an environment and to give it the illusion of three-dimensional depth.

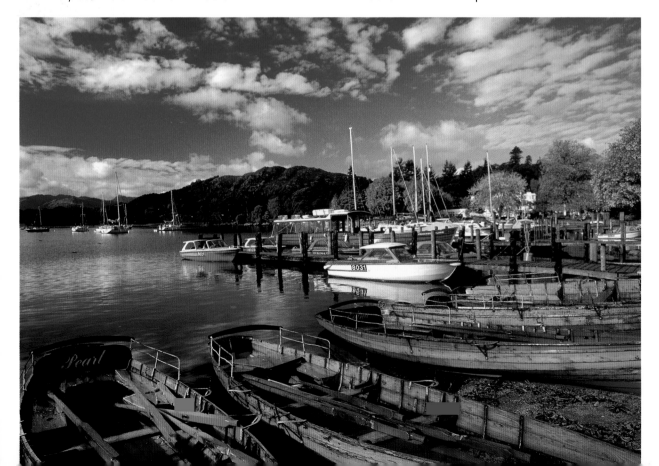

Wide-angle lenses are very useful for bringing out a sense of depth, and if you get in close to the foreground subject this can give more dynamic impact to the shot.

Viewpoint and angle of view

It is a very rewarding exercise to spend time walking around your subject to see whether you can improve on your initial viewpoint. In many cases you will find several angles that all work well, and by using different focal lengths (wide and telephoto, for example) and changing your position, a strikingly different feel can be created for the same subject.

Remember to change your angle of view, too: get down on your knees or stomach and shoot from lower down, or climb up to a higher vantage point. Shooting from an unusual angle keeps the image fresh and provides the viewer with a new way to look at the world, especially if you are photographing a well-known feature.

▶ *Changing viewpoints*
Walking around your subject and looking at all the different viewpoints is the best way to create striking images. Here the London Eye takes on very different qualities when shot from unusual angles.

Rule of thirds

This is the classic rule of composition. The ancient Greeks knew that placing the subject of a picture slightly off-centre, on a 'third', gave a more pleasing composition. Most successful photographs, when examined, can be seen to use this rule in one way or another.

It is a common mistake among novices to place the subject slap-bang in the middle of the frame. This is often because with auto-focus cameras the point of focus is in the middle of the viewfinder. More sophisticated cameras allow you to change the focus point to the side or top.

The rule of thirds is only a guide, however, and the final positioning doesn't have to be spot-on. In the shot on the right you can see how it is possible to mentally dissect the scene into thirds and place the subject over one of the overlapping points. Skies and seas look much more balanced when not symmetrical and centred.

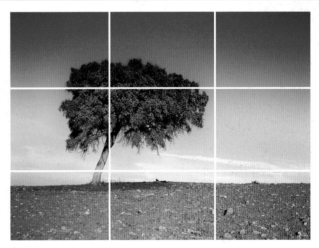

▲ *Rule of thirds*
This shot shows the four points of intersection where you should place your subject and other elements within the frame. The land follows the bottom third, and the middle of the tree, which is the subject, is placed on the top left intersection.

Breaking the rules

As with most things in life, rules tend to be broken at one point or another. This can allow for more unusual and artistic interpretations of a scene, but you should master the basic rules before trying to bend them; at least you will be able to back yourself up by explaining why you intentionally broke the rule of thirds.

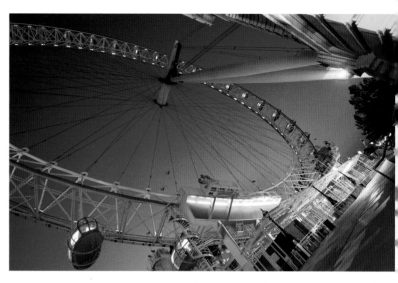

Rule-breaking ▶

This shot was deliberately taken from an obtuse angle. The camera was rested on a camera bag for support.

Framing the subject

A frame, which can be natural, such as a tree branch, or artificial, such as a brick wall, helps the viewer to concentrate fully on the subject. Whenever you come across a frame see if you can include it in your image. It is worth shooting frames to be used in other photographs.

Cropping

Especially if it is to remove unwanted and distracting detail, cropping is best achieved in-camera by using a zoom lens or moving your viewpoint if necessary. Zooming allows you to re-frame your chosen subject quickly and precisely, particularly if the subject is moving. If an animal or person keeps getting closer, you need to re-assess the composition constantly, so learning to crop and re-compose is vital. In-camera cropping or re-framing is better, because severe cropping of the image later on using a computer can cause an unacceptable loss of quality. Try to use the Crop tool in your image-editing program for fine-tuning an image rather than hacking it about.

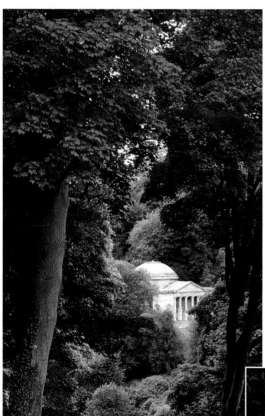

▲ **Natural frame**

A gap through the trees has created a natural frame for the temple folly. A telephoto lens was used to compress perspective and make the main subject bigger in the frame.

◀ **Framing for focus**

Here the overhanging branches of the trees were used to create another natural frame for the subject. Looking up through the branches also focuses attention on the building.

Portrait vs landscape

The camera is designed to sit comfortably in your hand to take pictures in a landscape or horizontal format. Turning the camera on its side to create a portrait or vertical format is more awkward, and many people don't bother to do it, thus missing many exciting picture variations. Tall buildings will often fit into the frame without any distortion from converging verticals, and you can exaggerate them even more if you move in close. Most close-ups of the human face work better in the vertical format, as it fits the shape of the face and body so well.

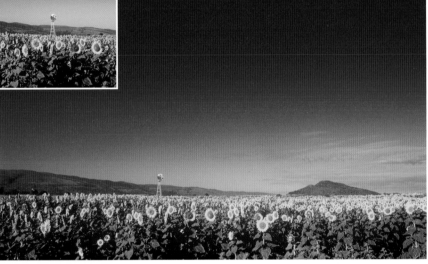

◀ *Switching picture formats*
Here you can clearly see the different effects that can be achieved by moving between the portrait format (above left) and the landscape format (left). Remember, just because you are photographing a landscape doesn't mean you always have to shoot it in landscape format.

Filling the frame for impact

Is that Uncle Harry in the shot or the Statue of Liberty? So many pictures could be improved simply by getting closer to the subject. People often forget that the human eye sees things bigger than they are in reality. The brain knows there is stuff out there on the periphery but ignores it to concentrate on the central area of vision, while the camera records all the peripheral area in sharp focus.

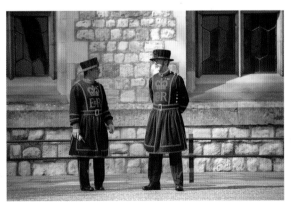

◀ *Filling the frame*
Of these two images of the same subject, the shot taken closer up has far more impact. Also note that the camera was turned on its side to the portrait format to maximize the shape of the Beefeater's face.

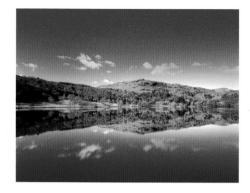

▲ *Natural reflections*
Although this reflection could be faked in Photoshop, it is quite natural. Early morning is often best, before the wind picks up speed and causes ripples on the mirror-like surface.

Symmetry ▷
A small pond has created the perfect foreground interest in this shot, as well as allowing a beautiful reflection to be captured.

Distracting backgrounds

Take care with the background when composing your main subject. A telegraph pole coming out of the top of a head is a classic example of lazy photography. It can be corrected later, but why should you use up your valuable time on the computer with silly problems that can easily be sorted out at the picture-taking stage?

When photographing people, simply move them so the background is uncluttered. Leave your digital doctoring until it is needed for unavoidable problems, such as TV aerials or backgrounds that cannot be changed.

Geometric shapes, lines and patterns

We live in a world full of shapes created by humans and found in nature, and many shapes can be used as a basis for creating powerful images. We can also use shapes to concentrate the viewer's eye on the subject. As your experience grows, you should be able to combine many shapes into one image and create a pleasing composition.

▽ *Cityscape reflections*
Although found in nature, most symmetrical images are man-made. Architecture has many repeating patterns, but people have also created artificial symmetry in nature by planting trees or crops. The most successful symmetrical images in nature are reflections in water, where a mirror image is formed.

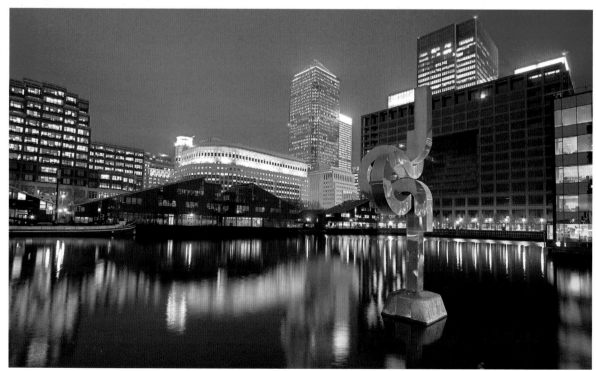

Diagonals

There are many diagonals, both natural and artificial, that you can use in your images; these lines and shapes create more tension in a photograph than straight horizontal or vertical lines. Diagonal lines, such as a path leading to a house or a diagonal branch that is attached to a tree trunk, are also perfect vehicles to lead the eye into a frame.

Diagonals ▶

In this shot the rows of ploughed soil on the left add texture and tension to create a very graphic image.

Converging verticals and receding lines

The phenomenon known as converging verticals often occurs when you look up or down through a wide-angle lens, especially when shooting buildings, whose parallel sides go from wide at the bottom to thin at the top. This can be used to good dramatic effect. If you were to follow the lines on, they would eventually meet at the vanishing point; the brain can understand this and subconsciously creates a sense of depth.

Having strong receding lines in a shot creates an incredible and instant feeling of depth and distance. Keep an eye out for paths, roads, bridges and railway lines, and make the most of them in your compositions.

Circles

The circle can be a strong shape in photographic compositions. Two of the most powerful and dramatic circles are the sun and moon, which appear in thousands of shots every year. There are many circles in nature, and humans have been influenced by this shape since the beginning of time.

▲ *Circular shapes*

Small cocktail parasols have been bunched together and backlit to create a colourful image. You can find and use the simplest props to create a striking image.

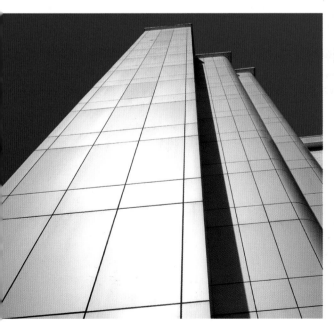

◀ *Converging verticals*

Although converging vertical lines can sometimes spoil a shot (see page 68 for how to correct these in Photoshop), in some situations converging verticals can add to the dynamics of a shot. This skyscraper appears to tower over the viewer, creating a tremendous sense of scale.

Understanding light and colour

Light is the main raw material that you need to make a photograph work, and it is the quality of light that can turn an average shot into a winning one.

Light can change in quality and colour, depending on the weather and the time of day: sunrise and sunset create beautiful warmth in the light, which eventually becomes cold and blue by midday. The sun is also at a lower angle when it rises and sets, thus creating dramatic shadows that are lost by midday. These are the 'golden hours' that many landscape and fashion photographers prefer to shoot in.

It becomes harder to create a mood in a landscape as midday approaches – the light just becomes too harsh and unfriendly, and many photographers pack up and go home. Of course, it is still possible to shoot effective and eye-catching pictures at this time; you just have to be more realistic about the type of subject matter you can shoot successfully.

◀ *The power of sunlight*
The difference a bit of sun can make to a shot is obvious from these examples. The distant farmhouse was shot on the outward (above) and return (below) journeys.

When to shoot for maximum impact

Dawn offers the photographer the first chance to capture some glorious light. Sunrise is calmer than sunset, and there is often no wind, so lakes can be mirror-still allowing you to capture the perfect reflection. Sunrise is essentially the reverse of a sunset, so twilight-style shots can be shot before the sun rises. It can be difficult to know exactly where the sun will rise, but there should be a glow appearing on the horizon to guide you. Colours are often more muted and cooler than at sunset, as there is less haze removing the blue end of the spectrum.

As daybreak occurs the world is flooded with golden light, and texture and shadows create a depth to the land. You must already have your shot set up and shoot quickly, as this light lasts for only 20–30 minutes.

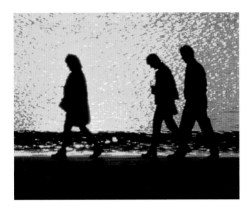

Just as with dawn, the time just before and after sunset should be one of your most productive times, as the light is again at its best. You should be able to plan exactly where the sun will set in your shot.

Colour temperature

Visible light, which is an electro-magnetic wave, is made up of the colours of the rainbow, or what we call the spectrum, and everything we see is made from these colours. There is also light of other wavelengths that we can't see, such as infrared and x-rays, but whose effects can be captured using special filters.

The colour of light changes throughout the day as one part of the spectrum becomes more dominant. When the sun is lower in the sky, the light has to travel further through the atmosphere, which helps to cut out the shorter, blue wavelengths. This is why sunrise and sunset are warm in colour: when the sun is high it takes less time for the light to travel, and it appears to be bluer.

These colour changes are described using a table measured in degrees Kelvin ($^\circ$K). A tungsten lamp is 3,000°K, sunrise and sunset are approximately 3,000°K, midday is 5,500°K, an overcast day is 7,000°K, and a clear blue sky up in the mountains is 12,000°K.

◀ **Silhouettes**
Sunsets are perfect for creating silhouettes which make for truly powerful images. In this shoreline scene shot at sunset, the people are deliberately underexposed to make them record as black shapes. The colour of the sun reflected in the water adds impact.

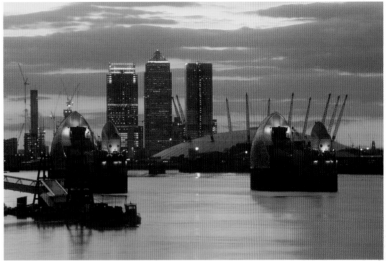

▲ **Sunset cityscape**
The lights on the buidings and river structures add to the glow of the sky and reflections in the water.

◀ **Time of day**
These two shots show the way in which light changes throughout the day. It is often rewarding to return to a location at different times of day and year, as the results can be radically different.

White balance

The human brain can automatically correct colours to mimic a more natural daylight source, so white objects remain white under many different light sources. Cameras simply record the colour of the light in a mathematically correct way, and you need to alter the colours in order to create a correct colour rendition of a scene.

Traditional film has always been balanced to midday for natural colour results, and you have to use a bewildering array of filters to correct it if the light source changes. Digital cameras use more sophisticated means to calculate the colour temperature of a scene: the white balance uses a system that automatically adjusts the colour of a scene to give a natural colour.

Most cameras have auto white balance, which gives correct results most of the time. Some cameras allow you to choose from a selection of predetermined settings that you can manually select from the menu. The main reason for overriding an automatic setting is to deliberately keep a colour cast, such as the lovely warm glow of a sunset, which may be neutralized using the auto setting.

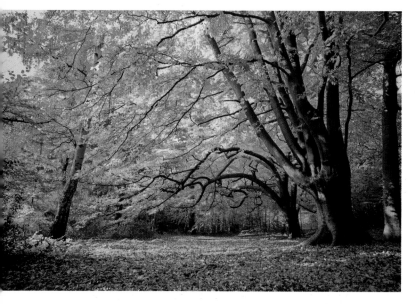

Auto settings and when to use them

Incandescent: Set camera to this setting when shooting indoors under tungsten lighting.

Fluorescent: This would normally give a green colour cast without being corrected.

Direct sunlight, **flash**, **cloudy** and **shade** all give variations of natural daylight. You can also fine-tune the preset white balance settings via the menu or white balance button. This setting is particularly useful with fluorescent lighting, which comes in many variations.

The best cameras also allow you to create your own preset white balance for the most accurate means of colour balance under mixed lighting. You must fill the frame with a white or neutral grey card or subject (such as snow or white paint) and take a measurement, which is stored in the camera. The Kodak pocket-sized grey card is perfect for this job.

◄ *Harmonious colours*
The colours in this shot all lie next to each other on the colour wheel. Mother Nature can always teach us a thing or two about colour harmony.

Colour harmony

Harmonious colours lie next to each other on the colour wheel. When combined in an image they create a relaxing mood that is easy on the eye.

By toning down the colours so they are less saturated, you get a pastel effect. Dull, overcast weather or fog can create this effect, and all colours become more harmonious as they lose their vibrancy.

Single colours

The harmonizing effect can be taken to an extreme where only one colour exists in the shot. Sunset, sunrise or silhouettes can be dominated by one colour, and bad weather can create an almost complete lack of colour. You can also add one single colour using a filter or an image-editing software package. In a monochromatic picture, only one colour can be perceived.

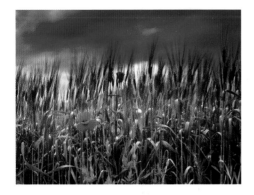

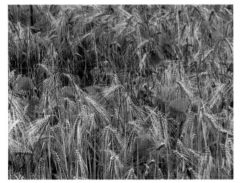

Creating atmosphere by controlling colour

All colours are made up from the three primary colours, red (R), green (G) and blue (B), as can be seen on the colour wheel below, and all cameras work on the principle of capturing information in RGB. Add equal amounts of red, green and blue and you get white.

We see the world in colour and its psychological effect on photographic images cannot be overestimated: imagine a red-hot desert in blue tones or a green sunset. Colour sets the tone of an image, but we can sometimes manipulate it to create a mood. This may just mean giving a helping hand – some extra orange to boost a pale sunset, for example.

To use colour deliberately to create a mood you first need to understand how colours affect us emotionally. Red, yellow and orange are warm colours and remind us of the sun and heat. They are life-giving and the strongest tonally, so they appear closer. Red also signifies danger in the natural world. Blue, purple and violet are cool colours that remind us of the sea, water and the sky. Green is the colour of trees and grass, and is a very natural colour. These colours are calmer and cooler, and tend to recede.

▲ *Discordant colours*

When you include colours that are opposite each other on the colour wheel, you get colour discord. Red poppies in a field of green clash for attention. Red is so dominant that you only need one poppy for the effect to occur – done deliberately, this can create a powerful image. In the second picture the poppies don't contrast with the yellow wheat. Yellow lies next to red on the colour wheel, so the colours in this picture are harmonious.

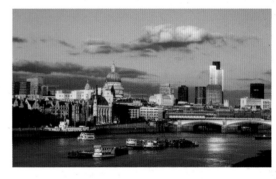

▲ *Colour contrast*

Here the warm late afternoon sunshine gives a warm glow to the buildings, contrasting nicely with the cool colours of the sky and river.

◄ *Monochrome images*

This monochromatic shot shows the use of a single dominant colour. It was taken just before dawn, when the light became more golden.

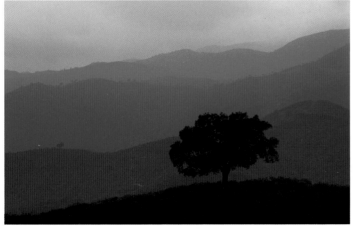

Computers

The hub of any digital photography system is the computer. You can buy a complete system or build up a system of separate items. The CPU (Control Processing Unit), or tower, is the heart of the system, and you should buy the best you can afford. Apple Mac computers have always been aimed at professional photographers and designers, and the OS (Operating System) interface is more user-friendly than PC Windows, but the choice is yours. If you already own a computer, it would be an expensive job to change your system and software, so it is best to stick with what you already have.

Monitors

Some Apple Macs and all laptops come as an all-in-one unit, combining monitor and computer. In such cases the monitor decision is already made, but most offer good quality. If you are looking for a separate monitor for a PC system, a screen with a resolution of at least 1280x960 should be used for best results.

Graphics video cards

The graphics video card runs the monitor, and the faster and more powerful the card, the finer the screen resolution and the faster the screen is able to redraw itself after an effect has been applied. Video cards use SDRAM (Synchronous Dynamic Random Access Memory) and are best used with at least 32 or 64MB of video memory.

Processor/chip speed

Processor speeds are a good guide to the raw computing power of your computer – the faster the better. Processing speeds change very rapidly and last month's model can quickly

become obsolete, as a glance at any computer or digital photography magazine should show you. However, a reputable dealer should always steer you in the right direction. Good bargains can be had when new models are released and suppliers are eager to shift older, slightly slower models. Good raw processing speeds improve the efficiency of power-hungry image-editing programs such as Photoshop.

Upgrading the daughter board

It is quite easy to upgrade many components on your computer. The processor card is often found on the daughter board attached to the motherboard. This should simply lift out so it can be replaced, but not all computer designs allow this to be done.

Replacing the processor card can have a dramatic effect on speed, and this is a good way to improve performance without breaking the bank. There are many third-party companies supplying upgrades for both Macs and PCs. Get advice if you are not sure.

Memory

The other major factor that improves speed and efficiency is the amount of RAM (Random Access Memory) your computer has: it can store and manipulate data far more quickly than the internal hard drive. If you don't have enough RAM, Photoshop uses the hard drive to create a temporary scratch disk where it stores the data. This is slower than using pure RAM.

RAM chips are supplied in various sizes, the most popular being 256MB, 512MB and 1024MB. Only newer machines can use the very large chips and each computer can use only a particular type of memory, so make sure you get the right type for your machine. Adding more RAM is a quick and easy way to improve the speed of your computer.

RAM is used by Windows and the Mac OS as well as Photoshop and other open applications, so it is often more efficient to work with only one application open at a time. Remember that because other applications use part of the RAM, you will need more than you think. As a rule of thumb, Photoshop needs three to five times more RAM than the image size, so for an image of 20MB you will need 60–100MB of RAM besides the RAM used by the OS and Photoshop, so you will need 160–200MB. Add extra memory-hungry benefits such as the History palette, which is also stored in the RAM as temporary memory, and you can see why 512–1024MB of RAM is required for serious work.

The percentage of memory can be altered by going into Photoshop's Preference menu. Choose Photoshop > Preferences > Memory and Image Cache, and then increase the percentage to 80% to achieve maximum efficiency.

Laptops ▶
The advantage of a laptop is its mobility and small size; modern laptops have a lot of memory.

The scratch disk

When Photoshop runs out of memory it has to assign the hard drive as a form of virtual memory. It can only use the main hard drive on your computer if you have a second hard drive installed to do the job.

Whichever hard drive you use, it must have as much free space as your available RAM – at least 1GB – or Photoshop may slow down dramatically or even display an 'Out of memory' sign.

Purging the History palette

The History palette in Photoshop uses up a lot of memory which can slow your progress down. There are two things you can do to improve efficiency. Go to Edit > Purge > Histories > All and Photoshop will remove all of your previous history states. This speeds up new manipulation, but at the cost of losing your ability to undo previous states. If you use the Dodge tool, for example, the History palette can quickly fill up. The other method available is to reduce the number of Undos to no more than 15 unless you have a lot of RAM installed on your computer.

File formats and saving

One of the first things you need to understand is how to use and store your images, both in camera and on your computer. There are several different file formats, which should be used for different purposes. All file formats have a 3-letter abbreviated extension of their name after the file name, such as .JPG, for correct identification. Large file formats, such as .PSD or .TIF, will soon eat up all your hard drive's memory, so make sure you buy a computer with a built-in CD/DVD burner to free up space.

Saving images on your camera

The first step is to choose the best file format for each picture you take. Generally it is best to keep the camera on a JPEG Fine setting for day-to-day work. If you shoot in RAW mode all the time, this will mean a lot more work opening the files on your computer. You need to choose the TIFF or RAW setting only for high-quality work where you might want to create large prints, or where you want the maximum possible quality in a smaller image.

TIFFs and RAW files

There are several different file formats to choose from on most good-quality cameras. TIFF files save all the data recorded during the exposure, and this universally accepted file format can be opened by many image-editing programs. RAW files have become popular, and allow the same high quality as TIFF files but in a smaller, more compressed file size so you can fit more on to your memory card. The downside is that you have to use the manufacturer's own software to open them.

In Adobe's Photoshop CS and Elements 3 you can use a plug-in that allows you to open RAW files directly in Photoshop – this can be downloaded from Adobe's website – and there are numerous tools for correcting RAW files. Most popular digital SLR cameras are catered for, with new ones being added. Raw files are often shot in 10-, 12- or 16-bit colour, which allows more subtle shades of colour to be saved.

JPEGs

JPEGs offer much greater file compression, allowing many more shots to be squeezed on to a memory card. An average RAW file of 5MB allows you to store 23 images on a 256MB card. A JPEG Fine at its highest setting creates a file size of 2.9MB, allowing 73 shots. If you were to choose the smallest JPEG setting, 950 images could be stored.

For serious photography, use only the RAW or TIFF settings, as these retain all the tonal detail. The JPEG Fine setting is great for general usage and still maintains a very high-quality image, but it does clip some highlight and shadow detail during the compression. If you are shooting a high-contrast scene such as a landscape with sky and land, detail may be burnt out using the JPEG setting. You can bracket shots, but remember that one well-exposed RAW file will take up less space than two or three JPEG Fine images.

Saving images on your computer

Once you have a memory card full of images and bursting at the seams, you need to download the images to your computer. You can link the computer directly to the camera via a USB cable or use a card reader. You will then be faced with a new group of file format options when you start working on your images. You will be familiar with some, such as .JPG or .TIF, as these are also on your camera, but there are several others to choose from as well.

Save a master copy

Never alter the original! Once an image has lost data it cannot be retrieved, so always keep originals as the master copy in their original format, and then, once opened, use the File > Save As option to create a new copy which you should re-name. If you just click File > Save, the original image data will be overwritten and the original data cannot be retrieved. Use the File Format menu to save camera JPEGs as a .PSD or .TIF and use Photoshop's options.

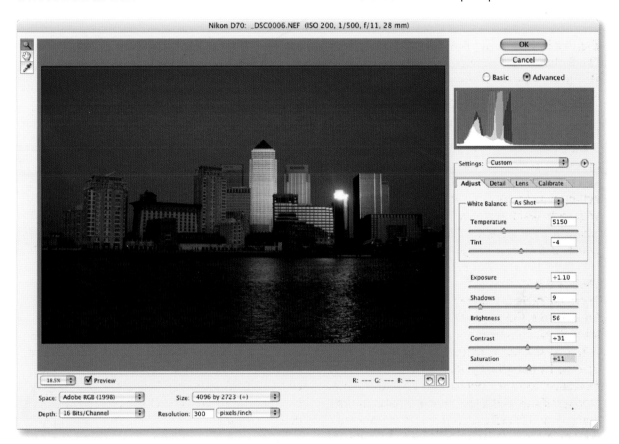

Keep on saving

You must get into the routine of saving your work at regular intervals. You may think it is OK to save at the end of a session, but on a long session you run the risk of losing valuable work. Computers crash and freeze, and you never know when this will happen – apart from when you least expect it, of course – so always be on your guard and keep saving.

▲ Camera RAW plug-ins

In Photoshop, click File > Open: the Open dialogue box appears. Select the RAW file that you want to open from your pictures folder, and remember to choose Camera RAW from the Format drop-down menu found in the bottom left corner. This will open the RAW dialogue box, which has many useful tools for correcting your image before opening up in Photoshop. Check Adobe's website for the camera RAW plug-in for your model. Copy or drag it to the File Formats folder found inside the Plug-ins folder inside the main Photoshop folder, which resides in your Application/My Computer folder.

The History palette

One possible escape route from disaster caused by failing to save is to go to the History palette one stage at a time until the problem is undone. Click on the original thumbnail icon at the very top to revert back to the original version. You will of course lose all the work you have done if this is necessary, so don't use this as a lazy 'get out of jail' card. Use Save As to create a new version, and keep saving in the future.

Note that the History palette information will disappear if you close the document window. When you reopen the file the History palette will automatically start again from scratch, so in this instance it would be too late to make any saving changes.

TIFF and native .PSD formats

You can save images using the standard TIFF format or using your software's native file format. Both are 'lossless' and save all the data without loss. Saving as a native format (Photoshop and Elements use the .PSD format) will guarantee that all layers, masks and settings are preserved, so you can continue working on a document at a later stage. When saving TIFFs you will have to choose from several settings, some of which flatten the image. JPEGs flatten all layers and remove alpha channels during compression. The .PSD format compresses some data that is similar, such as large areas of solid tone, to make a smaller file size, but a TIFF preserves all data exactly, producing the biggest file size.

▲ *JPEG 2000*

A variation of the JPEG format is JPEG 2000, which takes compression one stage further. In this very small file size of 128KB, the tonal values are better controlled and artefacts are much less of a problem. This format comes bundled in the Photoshop Goodies folder, and you have to install it manually. Only computers with the same plug-in can read JPEG 2000 files.

Some compression ▶
Saving as a high-quality JPEG (File > Save As and choose JPEG from the Format menu) with a setting of 12 has resulted in a file size of 3.7MB, which is about 61 per cent smaller than the file with no compression. The quality is still very high, as long as you don't want to make huge prints.

Full compression ▶
By re-saving the high quality JPEG file at 0 quality the file size has been reduced to 136KB, which would take about 40 seconds to download from the Internet using a 56KB modem. This is about the best compromise between speed and quality. JPEGs compress in blocks of 64 (8x8) pixels, and the downside to very small file sizes are JPEG artefacts caused by these blocks becoming too similar in tone, which can be seen even at normal magnification.These are often referred to as 'jaggies' because of the stepped boundary edges.

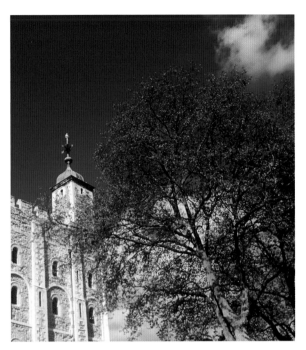

▲ **No compression**
Here you can see the TIFF-formatted image without any compression. There is no loss of quality, and even the finest details can be seen. It is a 9.7MB file, which would take about 30 minutes to download using a 56KB modem.

JPEG format
As in the camera, you can save files as compressed JPEGs to your hard drive. JPEGs are 'lossy', meaning that your image loses data through compression and the quality degrades the smaller you make the file size. You have a choice of saving from a maximum quality of 12 down to 0. JPEG is the best format for sending and viewing images on the Internet, as you can easily tailor their size to suit your individual needs. At their highest setting JPEGs can offer great quality that is difficult to tell apart from an uncompressed original, but don't re-save a JPEG over and over again, as quality degrades with each successive save.

Photoshop/Elements Camera RAW plug-in
Photoshop CS and the new Photoshop Elements 3 allow you to open and edit the RAW file format. Normally only camera-specific software can open RAW files, but Adobe's plug-in allows access to RAW files from many popular cameras. Nikon RAW files have the extension .NEF, and Canon have the extension .CRW or .CRV2.

Other file formats
There are other file formats that you are likely to encounter when processing your photographs. The main ones are listed below.

EPS and PDF
EPS (Encapsulated Postscript) and PDF (Portable Document File) are commonly used for design and reproduction applications, and are used where work needs to be professionally printed.

GIF
The GIF format is a popular file for saving images for use on the Internet. It is suited to logos and solid colours of vector art, whereas JPEGs are more suitable for photographs.

Sorting and filing

If you organize and store all your precious film negatives, slides and prints into boxes that are neatly labelled and dated, finding them is easy and straightforward. If they are a chaotic, disorganized mess, you will be in big trouble if you take this attitude to storing and filing your digital files – you will find it impossible to archive them to a CD or DVD, and it will take hours of sorting out to remedy the situation. If you then miss some and you need to re-initialize the hard drive (which wipes off all existing data) or you throw away a folder that you think is old and hasn't been fully copied, the files will be lost forever.

Be organized, methodical and up to date

A tidy, organized computer saves time hunting for images. Create a system of folders that can be accessed quickly and easily. Folders are like a filing cabinet: one main drawer folder that, when opened, contains many more folders, which themselves can contain more folders. Create a main folder for your original camera shots or film scans when you load the camera software on to your computer, create a folder for each job you are working on, and create a general folder to place all your folders in. You should end up with two main folders containing all your subfolders: originals and final images.

Saving camera files to the hard drive

Your camera should come with proprietary software that creates a place to save files within the hard drive. Windows will probably store this in the folder My Documents, but asks for a place when the camera software is loaded. Before loading the software, you could create a folder called My Photos on the desktop and ask it to save there instead.

In the example shown above, Nikon View 6 camera software has downloaded and saved the images, creating a filing structure in the folder called Pictures. Each time the camera is hooked up to the computer, a new folder is created and the images from the memory card are stored in it. You can then quickly access each folder to choose an image to work on.

Saving and finding images

The next stage is to create a specific folder that resides on the desktop until finished with. It can be placed in the main 'Finished Photos' folder or

My Documents afterwards. All images relating to this folder are saved to the desktop and then dragged to the appropriate folder. Opposite below left is a typical dialogue box for saving an image. Choose Save As and give your image a new name. Leave the file to save to the desktop as a default setting so you always know where it is.

If you lose an image, try using the File > Find command to locate it. In Photoshop/Elements you can try going to File > Open Recent to find the most recent files you have been working on. Ask it to Save As again and look in the Where or Save In pop-up menu to locate the file, then manually find it and drag it to where it should be.

Numbering and naming files

You can name an image by its location: for example, create a main folder called 'Florida Winter 2005' on the Desktop and then title individual images 'Sunset 001' or 'Sunset 002'. If you want them ordered you must use 001, 002, 003, not 1, 2, 3, to number images. Create a sensible system that is easy to navigate around.

Using the File Browser

The Photoshop File Browser lets you view, sort and process all image files. You can also create new folders, rename files, move or delete files and rotate images. To open in Photoshop go to File > Browse or Window > File Browser.

In the screengrab picture above right, the File Browser window is split into several areas. In the top left are the folders. Underneath these is the preview window, which shows an

enlarged photo of the thumbnail chosen, and under this is the Metadata palette, which stores all camera information and other infomation such as size, resolution and format. Next to this is the main preview window where you can see all the images in one folder. You can choose a folder or image by clicking on it.

Adding searchable keywords

The Keyword palette, next to the Metadata palette in the File Browser, lets you create and apply a keyword to a file. By adding keywords you can group files together by content. For keywording to work, each file must be given a separate keyword. To do this, click on the New Keyword Set button at the bottom of the palette or use the

drop-down menu at top right. Type in an appropriate keyword, which appears in the list. In the main window select the group of images that you want and then click the box next to the keyword you want to add, or double click the actual keyword.

Searching for a keyword image

In the File Browser menu at the top go to File > Search and a dialogue box will open. Choose an area to search in the Look In menu.

Archiving and backing up

Computers are prone to catastrophic failure – often an operating system failure where the computer crashes and you have to reinstall all your software. Re-initializing the hard drive may require you to wipe it clean, thus losing all data. It may be possible to save the old hard drive data, depending on your OS software; or it may be possible to hook up another computer using Firewire so you can copy data from the damaged hard drive. Seek advice if you aren't sure. In the worst-case scenario, the hard drive unit fails mechanically; in this case data cannot be retrieved at all. In some cases specialist companies can recover data, but the cost is prohibitive for non-professional users.

The safest and cheapest way to keep data in the long run is to back it up on disk on a regular basis. Many new computers come bundled with a CD writer or even a DVD writer, so make sure you choose this option, as it can work out cheaper than adding one at a later date.

CD/DVD writers

CDs can hold about 700MB of data and are very cheap. You have a choice of CDR/DVDR, which are written once only, or CDRW/DVDRW, which can be overwritten again and again. The latter are more expensive and are a waste of money for permanent storage – modern CD writers can burn a CD in minutes, so backing up data is fast and efficient.

DVD disks look just like CDs and can store 4.7GB of data, which equates to about six CDs and thus takes up less filing space. New DVD writers are now capable of writing to double-sided disks, which doubles the disk capacity to over 9GB. The advantage of DVD writers is that most allow you to burn CDs as well, giving you more choice. DVD burn speeds are a lot slower and thus take time to finish writing, but if you burn disks at the end of a session or while doing other things, this won't interfere with your normal computer work. It is always best to verify the disks afterwards to check for any flaws.

You can now buy portable CD writers that have a memory card reader attached. These are battery-powered, and can also be powered by a car cigarette lighter, so you can write to CD while on location away from a power source, as well as using a power source with your computer. CDs offer a safe and reliable method of archiving and allow you to free up valuable memory cards.

Other storage devices

As well as CD and DVD, there are numerous other ways to store your digital information.

External hard drive

You can buy an external hard drive or put an extra drive inside your computer to create more space. Hard disk failure is also possible on external hard drive storage units, so be aware that this is not safe for archiving. The safest and cheapest way of archiving at the moment is to CD or DVD. If you are using an external hard drive, you

must remember to archive to CD/DVD at regular intervals, not after amassing 30GB of data.

Portable hard drives with memory card readers are also available as an option for portable CD writers. They contain mini hard drives, so the same problems of disk failure and data loss may occur.

computers very quickly, making this a very user-friendly way of transferring files quickly and efficiently. You can use the disks to store files, but the cost is quite high compared to CD/DVD when storing large files.

Zip/Jaz drives

These have been around for some years and use very reliable disks that come in various sizes – 100MB, 250MB, 750MB, 1GB and 2GB. The latest versions use Firewire, so the drives can be plugged and unplugged between two

Magneto Optical (MO) disks

These offer a very stable method of archival storage on 700MB disks. This is a safe but rather expensive means of archiving material.

Creating a contact sheet

Contact sheets are an invaluable way to index your CDs and DVDs, saved in a plastic folder or similar. As long as each sheet is labelled with the name of the disk, you can create an index of all your archived pictures.

▲ **Step 1**

Create a folder containing all the images to be turned into a contact sheet. Make sure all files are in the correct mode; for example, Multichannel will not be recognized. The RGB mode is best.

▲ **Step 2**

In Photoshop, click File > Automate > Contact Sheet II to choose a folder from the computer. Click the Choose button to take you to Select Image Directory, from where you choose the appropriate folder. This will appear next to the Choose button. Click Include All Subfolders if you have folders within the main chosen folder.

◀ **Step3**

Create a document size for your contact sheet – on the left is a 25x20cm (10x8in) document with a resolution of 200ppi. Select Flatten All Layers unless you want to move the thumbnails around on the page afterwards. In Thumbnails choose the number of columns and rows. Click Use Filename As Caption and choose a font and font size if you like. Click OK to create a contact sheet of all the images in the folder.

Scanners

You may well use a digital camera now, but the chances are that you have old prints, slides and negatives gathering dust in a drawer somewhere. To bring your old images into the 21st century, allowing you to improve them using image-editing software such as Photoshop, you first need to scan them to create digital images. For this you will need a film or flatbed scanner.

◄ Flatbed scanner
A typical flatbed scanner will have a lid but higher spec flatbeds will also incorporate a film scanner in the lid, making them bigger but more flexible.

Flatbed or film?

Which scanner you choose depends on whether you have more film or prints to scan. Flatbed scanners are designed mainly for scanning prints. They usually allow scanning up to A4 (21x29.7cm/8¼x11¾in), so a 10x8in print can be scanned with no problems. Some more expensive models offer 'pro spec' quality and include a transparency adaptor. Prices are getting lower while quality continues to rise, so research the market thoroughly.

Transparency adaptors are great for occasional use, but if you have lots of slides and negatives to scan use a dedicated film scanner for the best results. Remember that the original negative or transparency has all the original information in the shadows and highlights and will give results far superior to a machine print unless the print was hand-printed by a professional lab. Film scanners are optimized for one job, and have good optics, a high dynamic range, great resolution and fast scan times. Most come with Digital ICE (Image Correction and Enhancement) or FARE (Film Automatic Retouching and Enhancement), which use infrared light and intelligent software to remove dust and scratches: this can save hours of retouching.

Dynamic range and optical vs interpolated resolution

A good flatbed or film scanner should give a dynamic range figure in its specifications. If it doesn't, this is because it is too low for quality results. A good dynamic range can capture all the difficult highlight and shadow detail, as well as the midtones. A dynamic range of 3.8 and above is common in quality film scanners.

The resolution of a scanner is also important to the final quality; most film scanners now offer a true optical resolution of 4,000–5,000ppi (pixels per inch). Beware flatbed scanners that claim to give interpolated resolutions of 8,000 or more, as this is software creating a bigger size, as with digital zoom in cameras, and is not a true optical resolution. If you must interpolate an image, use Photoshop or one of the new software packages that can make sizes bigger with clever fractal algorithm mathematics (see page 49). Always apply Sharpening after interpolating an image.

Getting connected

The type of connection depends on what is available on your own computer: there is no point buying a scanner with Firewire if you don't have the correct Firewire input socket, which is usually found on the back or side of your computer.

Make sure that any new computer has all the latest types of connections. If it doesn't, you may need to have a new input socket fitted, but your computer will need to have a spare card slot, which may be expensive or not even possible, especially with laptops.

SCSI (Small Computer Systems Interface)

SCSI (pronounced 'skuzzy') is a comparatively old (for computers) method for attaching an external device, but many internal devices still use SCSI, as it is fast and reliable. The main problem is that you must turn off the computer to remove the device or add a new one; connections are not 'hot-swappable'. You also need to give each device its own unique number, which is found on the back of the device. Few new computers have SCSI sockets, so you have to fit one yourself if you want to continue using an old but reliable piece of hardware.

USB (Universal Serial Bus) 1.0

This was the next evolution after SCSI and allowed true 'hot-swapping' of devices. With Macs, you simply plug in the USB and unplug it to use on another computer. PCs need you to click on an icon to ask for the device to be disconnected without turning off the computer.

This is a great asset if you share a printer between several computers, as you just need to unplug the cord to transfer. The main problem is that data transfer is not as quick as with SCSI, so some scanners come with both types of connection.

Film scanner ▶

This film scanner is much smaller than a flatbed but will produce superior results from original slides and negatives, at the expense of not being able to scan prints.

Types of Firewire connectors ▲

A is a 4-pin connector, B is a 6-pin Firewire 400 connector, and C is a 9-pin Firewire 800 connector.

Firewire 400 and 800 (IEEE 1394)

This gives the power and speed of SCSI data transfer at 400MB per second using 'hot-swappable' technology. Data-hungry devices, such as scanners, hard drives and DVD writers, have benefited from this technology. The latest version, Firewire 800, can transfer at 800MBps.

USB 2.0

The latest version of USB has a much improved data transfer rate. USB 1.0 transfers at a rate of about 1.5–12MBps, depending on the device being used, which is relatively slow.

Firewire transfers at an average speed of 400MBps, while the new USB 2.0 interface will go as high as 480MBps. USB 2.0 can also run older USB 1.0 devices.

Do your research

Before buying a scanner – or any other product for that matter – do as much research as you possibly can. Look at side-by-side reviews in specialist magazines, check the Internet for websites that have reviews, be sure to visit each manufacturer's website and download the PDF brochure to look at the finer points.

Scanning

Scanning your old negatives and slides is a time-consuming and laborious task, but is well worth the effort. Third-party software, such as Silverfast, can be better than the manufacturer's software, but for most people the original software will suffice. Always try to scan batches of images when doing non-computer tasks, so scanning doesn't interfere with more pressing computer jobs; save raw scans to a CD for archiving and then download them several at a time to work on. If you are not sure how to get the best out of your scanner software, do a basic scan that tries to capture as much detail as possible and do all the corrections in Photoshop/Elements. Learning how to use your scanner software will ultimately yield better-quality images, and tonal corrections can be carried out during the scanning process, thus saving time later on.

Choose the correct resolution for the job

Always try to match the scan resolution to the job in hand: it's no good creating a huge hi-res scan of 30MB if you want only a small image to put on the Web at 100KB – it will be 300 times too big for the job. If you want to use a photo for several different jobs, scan it at the highest resolution you will need and create smaller copies, using the guide here. This saves repeatedly scanning the same image. You need to use the scanner's maximum capabilities only if you intend to print images very large or want to use them commercially – then scan at maximum resolution to create the biggest file sizes possible.

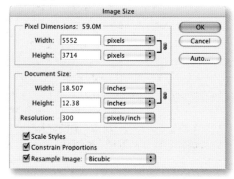

▲ **Step 1**

Open the scanner software and wait for the scanner interface to appear. Place a slide in the film scanner or a print on the flatbed scanner. Make sure prints are trimmed square and place them square against the side of the flatbed to avoid wonky horizons, which will need to be corrected later on. Use sticky tape to keep slides flat in their mount if they curl up. Press the Preview button to get a preview of your image.

Step 2 ▶

Using the Layout tools, rotate and flip the image if it is the wrong way up or reversed. This can be done in Photoshop, but it saves time to do it during the scan.

◀ **Step 3**

Type in your size and resolution settings. Use the Constrain Proportions option if necessary, but most scanners do this automatically. Choose whether the image is a positive transparency, negative or print.

Step 4

Alter the Levels or Curves if the image is particularly dark or light or has a bad colour cast – alternatively, you can choose the Auto option and let the scanner do it for you. You often have the option of adjusting colour balance and brightness/contrast. The correction tools may be similar to those found in Photoshop, so it is often best to leave any colour/tonal manipulation until later on in Photoshop/Elements. Once you have mastered these tools in Photoshop, you can apply this knowledge to getting near-perfect scans using the scanner software.

Step 5

Use Digital ICE/FARE if you have that option, which saves a lot of time later on manually removing any scratches or dirt with the Clone tool. You may have the option of Digital ROC (Reconstruction Of Colour) or Digital GEM (Grain Equalization and Management). Use ROC only on old, faded images, not recent, properly exposed images. Using these three functions dramatically increases processing time, so use them only if needed.

Step 6

If you have a Super Fine Scan button, use this to avoid any scan lines on the image, which may occur when scanning quickly. This makes scan times much slower, but there is a noticeable increase in quality. Bit depth is normally 8, but can be 12, 14 or 16. A higher bit depth increases colour depth, and both Photoshop CS and Elements 3 can open and work on 16-bit images. These images are twice as large as 8-bit images and the difference in quality is not that great, so 16-bit images are only really necessary for professional use.

Multiple Sample Scanning can rescue a dark image and stop a build-up of noise in shadow areas. The greater the sampling, the more times the scanner scans the image. Combine sampling with Super Fine Scan and ROC/GEM, and you probably have a scan time of about 30 minutes.

Step 7

Hit the Scan button and give the image a name when prompted.

Trade Tips

☛ When scanning prints on a flatbed scanner, make sure they are butted up against the side of the scanner. This stops them from being skewed when the document is open. This simple procedure reduces the need to straighten wonky prints – but it won't rescue a wayward horizon if it was shot like that.

☛ Try scanning 3D objects such as shells, hands, leaves or fabrics for interesting results. Remember to take care with the glass surface of the scanner, and drape a dark or black cloth over the object(s) for best results.

☛ Let the scanner warm up for 20 minutes before scanning, or make it do several pre-scans. This prevents any strange and unexpected colour shifts.

☛ Always carefully clean your prints or slides with a good-quality microfibre cloth or cotton wool. You can use film-cleaning spray if the slides are really dirty: Digital ICE works a treat, but it still uses other areas to clone the dirty areas. Take great care with old and delicate photographs.

☛ Use a small piece of sticky tape to stop slides curving in their mounts.

Recommended scan resolutions

Screen	Print	Press
(ie for use on websites)	(ie for printing on a domestic inkjet printer)	(ie for books or magazines printed on a commercial printing press)
▶ 72ppi with a suggested maximum size of 15x10cm (6x4in).	▶ 240–300ppi with a suggested maximum size of 25x20cm (10x8in) unless printing at A3-size (29.7x42cm/ 11¾x16½in).	▶ 300–350ppi to scan at maximum capability. A 35mm slide at 300ppi on a 4,000ppi scanner would produce a size of about 59MB, 5552x3714 pixels or 47x31.5cm (18½x12⅜in).

Digital images

Working with and understanding how digital images are created can be a bit confusing at first. Don't let this bog you down too much if you are struggling, as things will slowly but surely become clear as you start to work on your images – the important thing is to get stuck in and try out tasks first-hand. That said, there are a few core pieces of knowledge that can help you get a grip on the world of digital imaging more quickly, and which can save time in the long run.

Pixels and resolution

Resolution is the resolving power or sharpness of a lens, the number of pixels in a camera CCD sensor, or the number of dots in a print. Each factor along the chain determines the final quality and detail in an image.

Digital images are made up of millions of tiny squares called pixels. These are the building blocks of the digital world and are found in all bitmap digital images. Each pixel captures a single bit of colour and tonal information to create the final image. A 6-megapixel camera with a size of 3008x2000 pixels can record using 6,000,000 pixels, which is obviously better than can be achieved with a 2-megapixel camera.

The more pixels you have with which to capture the image, the higher the resolution and the finer the detail will be. Similarly, a scanner with a higher optical resolution that is capable of recording more pixels will produce better results. Finally, your printer must then be capable of printing all that detail, or you will have wasted your time.

300ppi

72ppi

200ppi

10ppi

▲ *Resolving resolution*

This group of images shows the effects of resolution and its effect on the final image. At 300ppi the image is perfectly sharp, and even at 200ppi there is little loss of detail. By the time you get to 72ppi the loss of detail is noticeable. The 10ppi image shows the pixellation effect that is produced when an image of low resolution is printed too big. The 200ppi image would have to be enlarged 65 per cent more than the 300ppi image to get a print of the same size, the 72ppi image by 739 per cent, and the 10ppi image by over 2,000 per cent. Using a higher resolution is similar to the principle of using a 2¼in transparency in preference to a 35mm one – the bigger the better.

Creating a bigger print size by using interpolation

If you try to take a 531KB image and make a 10x8in print, the image will look awful: there won't be enough information to create a smooth, continuous-toned print, and you will probably see the square pixels with the naked eye.

One solution is to interpolate the existing data to make more pixels. Here the computer looks at the existing pixels and makes a calculated guess as to what new pixels should look like.

This sounds great in theory, but in practice you can only go so far – if you try to create too big an image the computer has to fill in too many gaps, and the resulting image will look out of focus and smudged. You may get away with as much as a 50 per cent increase, but interpolation works best on high-resolution images where there is already plenty of data to play with. In the Image Size dialogue box tick Resample Image and increase the resolution, pixel dimensions or print size to interpolate.

There is now software on the market that uses complex fractal algorithms, which work better than Photoshop's basic interpolation, and this produces the best results.

Printing a smaller 6x4in image from a file that is 7x5in does not create the same problem of loss of detail, as in this instance what you are doing is throwing away data that is not needed, not guessing at new data.

Understanding resolution

1. If you start with a print size of 7x5in at 300ppi, you get a 9MB file size.

2. By altering the resolution you get a different print size. If you change the resolution to 240ppi, you get a print size of 8¾x6¼in.

3. If you change the resolution to 72ppi, the print size becomes a whopping 29⅛x20¾in.

The catch about resolution is that your prints will suddenly be bigger but not very sharp, because there is actually no extra information to send to the printer. To make bigger prints you need to have the extra data there in the first place. Note that the all-important pixel dimensions always remain the same; you are simply rearranging exactly the same amount of data into a space of a different size. Think of it as the universe expanding: there is still the same amount of stars or pixels – it's just that they are spread out over a larger space.

1

2

3

Now look at the example below, where the number of pixels has been reduced and the image size remains at 7x5in. The resolution has reduced to 72ppi and the file size has also reduced to 531KB. The computer has simply thrown away lots of data in order to create the image size at that resolution. With fewer pixels, the image will appear of poor quality. Here the universe has stopped expanding and millions of stars have simply vanished.

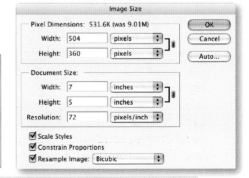

This is the formula for working out print sizes – try it for yourself:

pixels ÷ resolution = print size

eg 2100 ÷ 300 = 7 and 1500 ÷ 300 = 5

A 2100x1500 pixel image at 300ppi will thus print at 7x5in.

Finding your way around Photoshop

Mastering the basics of Photoshop is relatively easy, but knowing what each of the tools can do will help you take your image-editing one step further.

The desktop

When Photoshop is opened for the first time or the tools are re-set to their factory default, all palettes are opened and visible. This takes up too much space. In the top corner is a cross or red dot which removes the palette from the screen. Go to the Window menu to select them again. Use a monitor with a minimum size of 38cm (15in), and use the finest screen resolution possible with your monitor. The higher the resolution, the smaller the palettes display, allowing more space to work on your images, but you may find it more comfortable at a lower resolution. Macs allow you to hook up a second screen just for palettes.

Photoshop tools ▶

This is the layout of all the different tools found in Photoshop. The layout is similar in Elements.

▲ *Display*

The Display dialogue box gives a selection of resolutions.

The toolbox

Hover the cursor over a tool or any other area on the screen to see what it is. Click and hold down the mouse to see hidden tools and select a new tool by dragging over them then releasing the mouse to select.

The toolbox is grouped into several sections; the selection and move tools are at the top, the painting tools are next, then the vector and measuring tools; next is the colour selector, then the masking tools, screen viewing options and finally the quick jump to ImageReady. You can use the Tab key to toggle the tools on and off, which can help when working.

◄ Brushes
Many Photoshop/Elements tools use brushes to apply a variety of effects.

Palettes

In Photoshop palettes are where many commands and functions are carried out. On the right of the options bar is the Palette Well, where palettes reside and open when clicked on. This allows many palettes to be cleverly stored, keeping the desktop clutter-free. Click on the arrow in the top-right hand corner of a palette and select Dock to Palette Well. Try keeping Navigator, which allows quick and easy zooming, and Layers open on the desktop and the rest in the options bar.

Brushes

The options are usually the same for each Brushes tool. Access is via the options bar for the tool chosen or via Window > Brushes in the main menu at the top. Hardness adjusts the edge of each brush stroke from soft to hard. Opacity reduces the strength of the colour, and Flow reduces the amount of colour applied. Diameter changes the size of the brush.

Opacity sliders

These allow precise control of transparency of layers or colours. Experiment with different settings so you can begin to understand all the effects it is possible to create.

Keyboard shortcuts

One trick of the trade is to use keys to bring up various commands and functions. Macs use Command and PCs use Control, but both do the same thing. Here are a few of the most popular ones. For more go to Help> Photoshop Help> Keyboard Shortcuts:

Cmmd + S	Save
Cmmd + S + Shift	Save As
Cmmd + C	Copy
Cmmd + V	Paste
Cmmd + Z	Undo
Cmmd + A	Select All
Cmmd + D	De-select All
Cmmd + L	Levels

Single letters access the toolbox icons. Each icon shows the shortcut key in brackets.

B	Brush tool
C	Crop tool
S	Clone/Rubber stamp tool

Options bar

Each bar is unique to a tool, although there are many areas of crossover, such as brushes and feathering. Each box has an arrow indicating a drop-down menu or slider where further options are available.

▲ Options
The options bar is an important area, as it allows many variations to be used for individual tools.

Brightness and Contrast

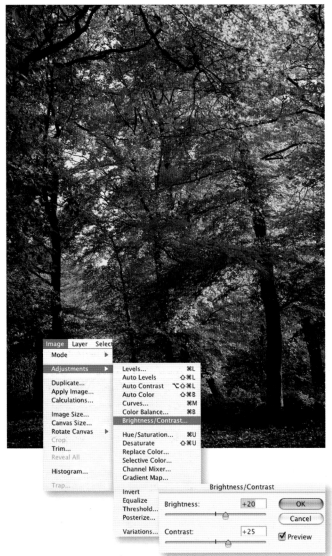

One of the first and most basic corrections that you can make to your digital photographs is to alter the brightness and contrast of the image. When using Photoshop, this can be done using a simple command that allows you to make basic but effective tonal adjustments quickly and easily.

Using the command

Most digital cameras produce a slightly soft, low-contrast image unless you have used the menu to alter the standard camera settings. This can be quickly corrected using the Brightness/Contrast command to brighten or darken the image and to boost or reduce contrast. Follow the sequence here to make basic corrections to your pictures.

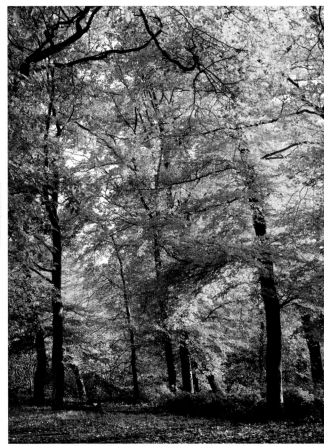

Using Brightness/Contrast ▲ ▶

In the menu at the top of your screen click Image > Adjustments > Brightness/Contrast. A dialogue box opens that has two sliders, which either increase (drag to right) or reduce (drag to left) contrast and brightness. This is a useful quick fix that works better if you apply some simple selection to the image first. Here you can see that the top picture is too dark and low in contrast. This is a common problem with digital shots, but it can be easily rectified to create a brighter result.

Levels and Curves

Levels is a much more powerful tool than the very basic Brightness/Contrast tool. It allows you much finer control over your tonal image adjustments. Curves is similar to Levels, but gives much greater control over the tonal values.

How Levels works

The Levels command (Image > Adjustments > Levels) allows you to correct tonal and colour balance much more finely than with Brightness/Contrast. The histogram accurately depicts all the tonal values: dark tones on the left, midtones in the middle and highlights on the right. Underneath are three sliders for altering the tones. To correct the shadows, move the black slider in to meet the start of the histogram. Do the same using the white slider for the highlights. The grey slider alters the overall darkness or lightness.

Channel
Leave this in RGB mode unless you want to alter the colour balance of each individual channel.

Input Levels
The tonal range of an image goes from 0 (pure black) to 255 (pure white). The midtones are around 128 but are represented by a value of 1.00. A lower value than 1.00 gives a darker image, and a higher value gives a brighter image.

Output slider
This should generally be left alone. It is useful for creating faded images by pushing the black slider up.

Histogram
What looks like a mountain range is the histogram's way of showing where each pixel is. The width shows the tonal range from black to white, while the height shows the number of pixels, one on top of another, at each point along the tonal scale.

Black input slider
Dragging this slider to the right makes the darkest tones pure black.

Grey input slider
This affects the overall brightness of an image. Move to the right to darken and to the left to brighten.

White input slider
Dragging this slider to the left increases brightness in the lighter tones. Use with the black slider to increase contrast.

Load and Save
These allow you to save and reuse a setting you like.

Eyedroppers
These allow you to set the black and white points manually by eye. Choose the black eyedropper and click on the area you want as your darkest tone; use the white dropper for the highlights. This automatically removes any colour cast as well. The grey dropper corrects a colour cast only, but for this you must choose a grey tone, which may not always be easy to find.

Auto and Options
Clicking on Auto is the same as using Image > Adjustments > Auto Levels. The Options box gives you extra control; use this as a quick fix only.

Preview
This allows you to see the effects of any commands you make. A good tip is to keep checking and unchecking the preview tick box to see instantly what the image looked like before and after the adjustment to the levels, to check that you are actually improving the image.

◀ **Reading histograms**
The Levels histogram shows a lack of highlight information on the right, typical of an underexposed image. Most shots can be rescued unless the exposure is so extreme that there is no information to work with.

Curves explained

This is a similar tool to Levels but gives much greater control over the tonal values. Levels has three sliders to control tone but in Curves you can place up to 16 anchor points on the diagonal line at any one time. In practice it is best to keep the adjustments simple. Curves can also be used to create bizarre colour changes similar to solarized and posterized prints.

The 45-degree diagonal line can be pushed and pulled up or down. Click anywhere on the line to create a new anchor point. The bottom of the line (0) represents shadow tones, the middle (128) represents midtones and the top (255) highlights. Attaching anchor points at these three points would give the same control as Levels. The greater control lies in being able to add further anchor points. Add one in between the shadow and midtones and you can tweak the darker tones only; similarly, you can adjust the highlights from an anchor point at the midpoint between highlights and midtones.

Curves can also be used to adjust each individual layer in RGB or CMYK mode so colour can be changed very precisely. You can use the black, grey and white eyedroppers to alter colour balance as in Levels. Use the black and white to alter contrast and automatically set the correct colour. Use the grey to alter colour only, choosing a midtone grey for best results.

◄ Poor Curves

Here a basic Curve, where the lower midtones have been darkened, has yielded an unsuccessful result. Although the image has darkened in the shadow areas, it has also darkened in the highlights and midtones. This has created an image that is too dark.

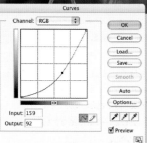

▲ Good Curves

Hold down the Alt/Option key and click on the grid to change it from 16 squares to a more accurate 100-square grid. You can 'freeze' the midtones and highlights by placing several anchor points above the central midtone point; these prevent any changes unless you physically drag them. The lower anchor points can be dragged down to darken the shadow areas without affecting the highlights. The final result is much better: only the areas of the image that needed attention have changed.

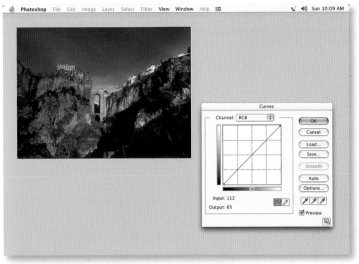

◀ This is the original photograph and Curves dialogue box. The histogram found in Levels has been replaced by a 45-degree line and the tonal values have disappeared. Use the following variations as a guide to altering images in Curves.

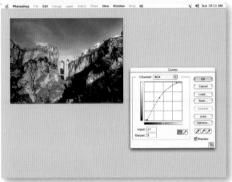

◀ This is similar to tweaking contrast and midtones in Levels. Move the top anchor point to the left to brighten highlights. Move the bottom point to the right to darken shadows. Move the middle point up and left to brighten the whole image.

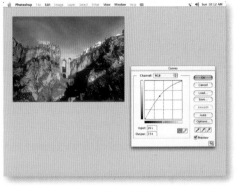

▲ In this version only the midtones of the image have been altered, by moving the middle of the line.

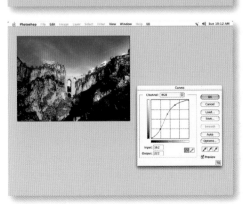

◀ The next two examples show how to darken or brighten for effect. This curve shows how to darken shadows and midtones. Create an anchor point for the highlights to stop them being altered.

◀ Here only the midtones and highlights have been altered.

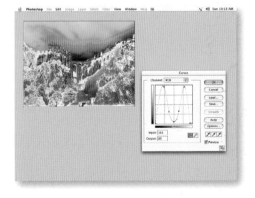

▲ This is where the difference in colour control compared to Levels becomes obvious. You can alter many more points along the line to create some amazing effects. The permutations are endless, and you can have fun finding out new variations. If you find one that you like, use the Save button to store the curve; click on Load to retrieve it. You can use the pen icon to draw a curve of your own design.

Hue and Saturation

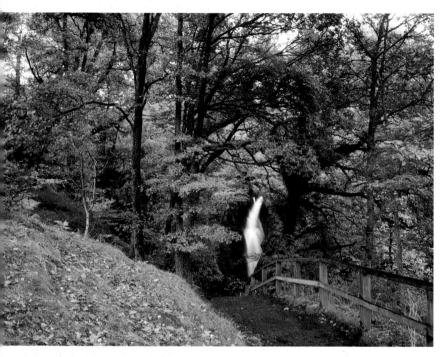

The Hue/Saturation command allows you to adjust the hue, saturation (intensity) and lightness of an image. You can choose to alter just one colour from the drop-down Color menu or alter all colours at once. This is a very powerful and precise way to alter colours and is useful for increasing colour saturation in most photographs, but don't overdo the effect – photos can look very unnatural if you go overboard. The Hue control physically alters the colour when you drag the slider; with this it is possible to fine-tune the colour or create a dramatic colour shift.

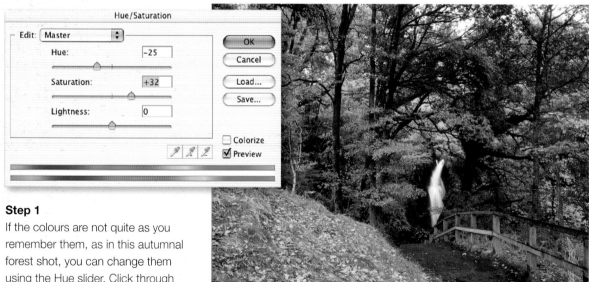

Step 1

If the colours are not quite as you remember them, as in this autumnal forest shot, you can change them using the Hue slider. Click through Image > Adjustments > Hue/Saturation to open the dialogue box, which is found in the menu at the top of the computer screen. You can also use the keypad shortcut Cmmd/Cntrl U.

There are three sliders. Ignore the Lightness slider, which just adds white or black to the colours, but drag the Hue slider to -25. In this example the Edit menu has been left as Master, but you can also tweak individual colours. In this instance the colour intensity has been increased by dragging the Saturation slider to +32. This quick and simple fix has transformed the dull and lifeless colours, and this has given the image a much-needed boost.

Step 2

You can create some interesting colour effects that are very similar to colour infrared film. In traditional photography you would need to load the film in complete darkness, use coloured filters and keep your fingers crossed that the effect worked. The beauty of the computer is that you can try out a multitude of effects quickly and easily and discard the ones you don't like. In example 1, the Hue slider was dragged to -35 to create a more pink/red effect. In example 2, the effect was increased even more by dragging the slider to -83. In example 3, the Hue slider was dragged to the other end of the colour scale to create a moonlit effect.

1

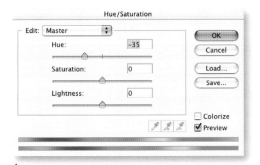

1

2

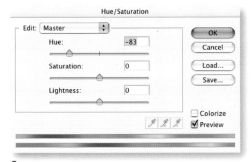

2

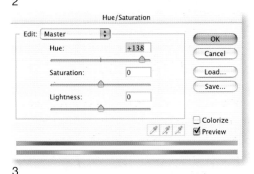

3

Removing a colour cast

Colour casts are a common problem, even with digital cameras. Although most cameras have an auto white balance, which should, in theory, correct any colour cast, this doesn't always work perfectly, so it is useful to know how to correct a colour.

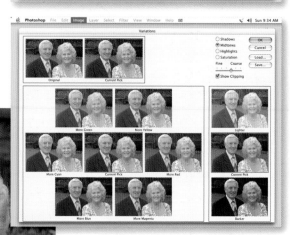

▲ ▶ Step 1

This image clearly shows that there is too much blue, making the picture feel cold and uninviting. Image > Adjustments > Variations brings up a dialogue box with numerous colour variations to correct the image.

Select Midtones for a general colour correction. Altering the Fine/Coarse setting allows you to create a subtler or more vigorous colour change. Click the Show Clipping box to see the effect before applying it. As well as altering the colour, you can make the image lighter or darker using the right-hand panel.

◀ ▲ Step 2 (Photoshop CS)

By adding more yellow the image has been corrected quickly and easily. In the top left corner, Current Pick shows the effect after applying a colour correction, which lies next to the original image, to allow an instant comparison.

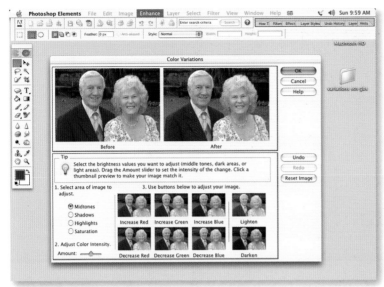

◄ Step 2 (Elements)

The dialogue box in Elements is slightly different from that in Photoshop CS. The Decrease Blue box adds yellow to an image, the Decrease Green adds magenta, and the Decrease Red adds cyan. To correct a blue colour cast, select the Decrease Blue option. In the same way that you can remove a colour cast, you can also deliberately add one to create a mood.

Warming up ▼

The 85 series warm-up filter was applied using a density value of 62%. Check the Preserve Luminosity box to maintain existing tonal values.

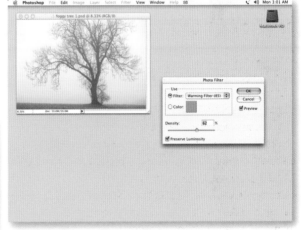

Photo Filter

Found in the new CS version of Photoshop and Elements 3, this allows you to create the effect of traditional photographic filters, which would normally be placed over the lens at the shooting stage. With this you can quickly add a filter effect or remove a colour cast.

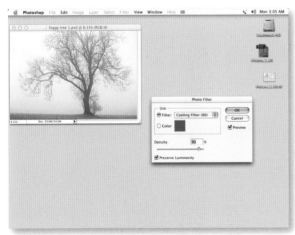

◄ *Cooling down*

The 80 series cool-down filter was applied using a density value of 90% to create a blue effect, which adds to the cold, foggy, wintery feeling nicely. In most cases it is best to use a colour that is sympathetic to the image.

Colour correction If a photo is:

- too cyan ▶ increase red
- too yellow ▶ increase blue
- too magenta ▶ increase green
- too green ▶ decrease green or increase magenta
- too blue ▶ decrease blue or increase yellow
- too red ▶ decrease red or increase cyan

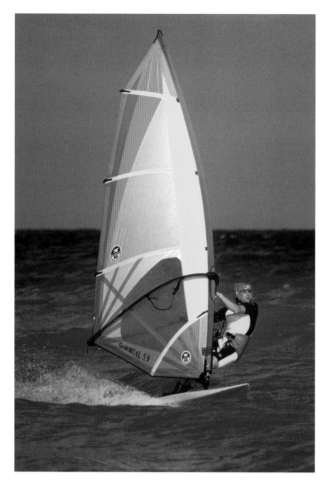

Cropping and straightening

We all aim to take perfect pictures, but there will be many occasions when you will have to straighten a horizon and then crop an image. This is routine cleaning up and should be done before any other corrections are made. To do this you need to use one of the powerful suites of tools from the Transform command submenu. It is quite possible you will use Rotate, Scale and Perspective all on one shot, so you should get to know this area, as you may use it a lot.

▼ **Original shot**

The original composition of this shot can be improved dramatically by cropping in on the focal point of the image and by straightening the horizon so that the shot is level.

Step 1

Both the cropping and straightening commands are simple to master. In order for the Transform tool to work, you first need to turn the Background into a layer so that you can apply a transformation or opacity change to it. Double-click the name, rename it in the New Layer dialogue box and click OK.

◄ **Step 2**

Go to the menu bar at the top of the screen and choose Edit > Transform > Rotate to bring up a border with handles at each corner and in the middle. Turn on the grid with View > Show > Grid, or use the keyboard shortcut Cmmd/Cntrl '. Toggle on and off at will. The grid allows precise positioning of straight lines anywhere within the image.

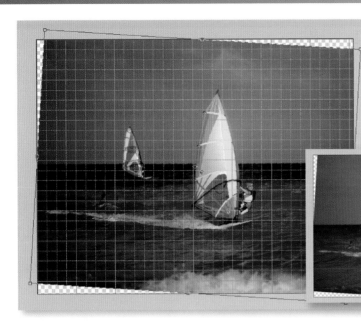

◀ Step 3

Drag one of the corner handles to rotate the image – you can reposition the centre point to offset the rotation if needed. When you are happy with it, hit Return/Enter or click on the tick in the options bar. Click on the cross or Cmmd/Cntrl Z to undo the rotation. You should now be left with a corrected horizon but uneven and unsightly edges, which next need to be tidied up, this time using the Crop tool.

Step 4 ▶

Select the Crop tool from the toolbox. Drag the mouse from one corner of the image to the other, and a bounding box appears exactly like the Rotate command one. Drag any handle to create a new crop shape. Hold down the Shift key as you drag to constrain the proportions to the original shape.

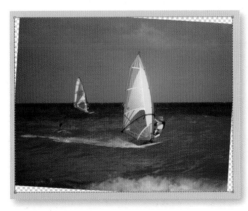

▼ Step 5

You can move the crop area by dragging the mouse pointer from within the selected area. A dark area appears around the area to be cropped as a guide. The colour and opacity can be changed to suit your own liking by selecting the Shield in the options bar. Press Enter/Return to crop.

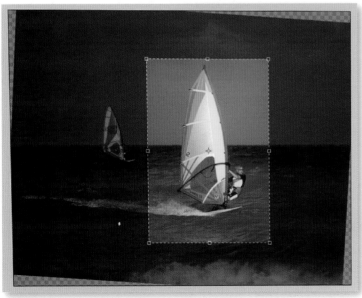

Sharpening images

Whether you are shooting on a digital camera or scanning in film, a small amount of sharpening is necessary to counteract any softness in the image. It is better to leave sharpening as the last job after all other correction work has taken place, as the effects are irreversible once applied. Try to set the camera or scanner to use little or no sharpening at the capture stage. Some cameras have settings that can be manually overridden, so you can turn off the sharpen setting. Sharpening causes quite harsh contrast changes at pixel edges, and to apply a filter or tonal correction after sharpening, especially a contrast change, will degrade the image quality. Sharpening can rescue soft images where focusing is slightly out, but cannot correct pronounced focusing problems or camera shake. There are usually several filters to choose from, but only the Unsharp Mask filter has parameters that can be finely tuned.

▲ *Average settings*
This average setting for sharpening images shows a subtle increase in sharpness.

Unsharp Mask
Found in the Filter submenu Sharpen, this has three sliders in the dialogue box that alter the sharpnesss settings.

Amount
The slider goes all the way up to 500% and increases the sharpness by increasing the contrast of adjacent edge pixels. A setting of 200% is a good starting point.

Radius
This gives the illusion of greater sharpness by increasing the number of adjacent pixels that are affected by sharpening. A setting of 1.3 is a good place to start from.

Threshold
This determines how many similar pixels are sharpened: the lower the setting, the more pronounced the effect on flat areas of colour. Use a lower setting for more graphic images and a higher setting to retain the delicate feel for portraits and skin tones. Start with a setting of 10, but increase this to 20 for skin tones.

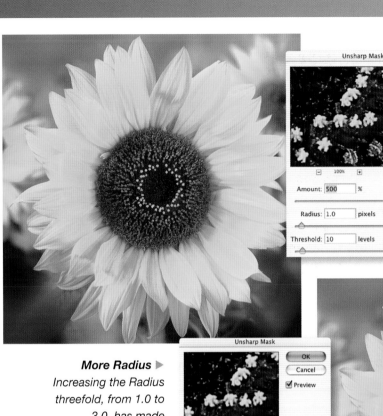

◀ **More Amount**
Increasing the Amount has given a much stronger effect that is good for graphic images. You can select different areas and apply different settings; here after a general sharpen overall, the centres were sharpened for a more pronounced effect.

More Radius ▶
Increasing the Radius threefold, from 1.0 to 3.0, has made the bright areas more contrasty.

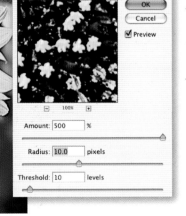

◀ **Too much Radius**
A radical increase in the Radius setting, this time more than threefold, from 3.0 to 10.0, has yielded an unnatural effect. Note the horrible blue fringing around the petals.

63

Dust and scratches

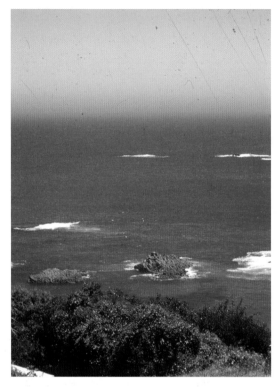

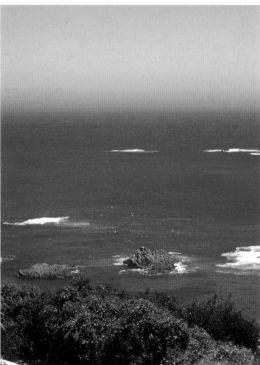

When scanning old transparencies, negatives or prints, the scanner records any dust on the surface. It also accurately records all scratches, even those invisible to the naked eye. This is mainly due to the light source of a scanner, which tends to be quite harsh and unforgiving. Always try to clean the film or print carefully and thoroughly before scanning, which will save a lot of retouching time later on, but use extra care for delicate old film: it may be best to do an initial scan for safety and then clean the film. Digital ICE or FARE automatically removes most scratches.

The Dust & Scratches filter

There are several tools and filters that can be used to remove unwanted blemishes from your images. Use the Dust & Scratches filter (Filter > Noise > Dust & Scratches) to remove small blemishes by carefully applying the filter to the entire image. There are two sliders used with the filter – the Radius slider controls how many pixels are looked at, and the Threshold slider determines the strength of the effect.

Do not use the filter above a setting of Radius 2, or the entire image will look out of focus. For dust greater than 2 pixels in width you need to select each blemish individually and apply the filter to the selection. Use the Lasso tool at a radius setting of 1 or 2 pixels to create small selections – use the Shift key to add to and the Alt/Option key to subtract from the selection.

Digital cameras and dust

Digital cameras with a fixed lens system are not normally prone to dust, as they are sealed units, but digital SLR cameras with interchangeable lenses are very susceptible to dust migrating on to the sensor. Newer models have a protective filter over the sensor but older models may not, and the dust can lie directly on top of the very fragile sensor. These cameras probably need professional cleaning, but newer models can be gently cleaned with a blower (remove the brush first). Alternatively, spray air from a pressurized can gently on to the sensor from a distance of 30cm (12in).

▲ *Before selecting dust*

◀ **Step 1**

Select the dust with the Lasso tool and feather it by at least 2 pixels to soften the edges. It doesn't take long to build up an area of selections. It is best to zoom in to 100% so you can see what you are doing. Keep selecting areas across the entire image until the job has been done.

Step 2 ▶

The final result is an image clean of small dust particles. The cleaner the original before scanning, the less 'dusting' is needed later on. Larger pieces of dust still present should be removed using the Clone tool or the Healing Brush.

Using Digital ICE or FARE

If your scanner is supplied with Digital ICE or FARE (offered only by Canon), this saves lots of time cleaning up images later on. It can do an amazing job and remove even deep scratches, and works by using an infrared beam to detect surface scratches and dirt. Remember that it still has to use information from the image to guess the corrections, so you still need to clean your film before scanning.

Feathering the Lasso tool

Rather than feathering the selections after drawing them, you can specify a feather radius in the options bar at the top of the screen. Every time you create a new selection, this is automatically feathered; in the bar above and the image to the right, Feather is set to 2 pixels.

Dodging and burning

For anyone familiar with the traditional darkroom technique of dodging and burning, these tools will be simple to master. But even if you have no darkroom experience, this technique can be learnt in minutes in the digital darkroom of Photoshop or Elements. The Dodge and Burn tools are very useful for quickly altering tone in small areas. The Burn tool makes an area darker, effectively increasing the exposure, and the Dodge tool makes an area lighter, thus doing the opposite.

The Dodge and Burn tools

The tools themselves are simple to use because you don't have to make a selection first. The three main variables are Brush size, Range and Exposure.

Choose a brush size to suit the job and use the soft round variety for a soft edge effect. Here a width of 400 pixels was chosen to give a wide brush stroke to darken the background. The size was reduced when finer detail around the fur needed to be darkened. Choose Midtones for the range so all colours are darkened equally.

Always use a low exposure setting to start with, and build up to a higher one later, as too high a setting can ruin the image.

▲ Step 1

The image should be darkened gradually all over, allowing you to assess at which point to stop, so as not to overdo the effect. Remember that you can use the History palette to go back several stages if you have darkened or lightened the image too much.

▶ Step 3

You may want to darken or lighten the highlights or shadows using the Range drop-down menu. Darkening often introduces unwanted colour saturation, which can be removed using the Sponge tool, found with the Dodge and Burn tools; you can use it in Saturate or Desaturate mode.

▲ Step 2

Zoom in close to work on small areas, and use a small brush size for finer control. Reduce the exposure to 10% or 20% for a more subtle effect, such as the edges of the lion's mane.

▲ Step 4

The final effect looks good but a small amount from the bottom, which was distracting to the eye, was cropped.

Correcting converging verticals

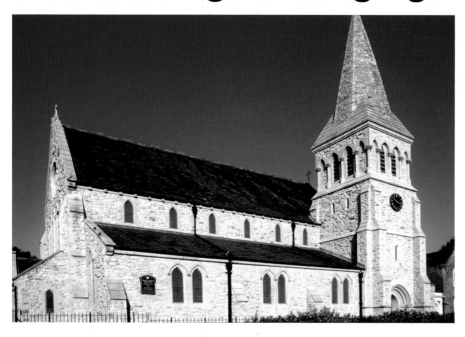

Many shots are ruined because the camera was pointed up or down at the time of shooting. This causes a distortion of perspective called converging verticals, where all the straight lines converge towards the vanishing point. The best way to avoid this when shooting is to move further back from the subject and zoom in further, as extreme corrections can cause a lot of the image to be lost during the process.

The tools themselves

The best tools for correcting converging verticals are the Transform tools found in the Edit submenu. There are several to choose from – for simple perspective correction you can use the Crop tool, but the most useful tools are Scale and Perspective; you often need to use both to create the best result.

The Crop tool

Step 1 ▶

Here the Crop tool was used to correct perspective in a shot where the camera was pointing up. Choose the Crop tool and make sure Perspective is checked in the options bar or it will crop the image in the normal way. Drag across the image from top left to bottom right to select it.

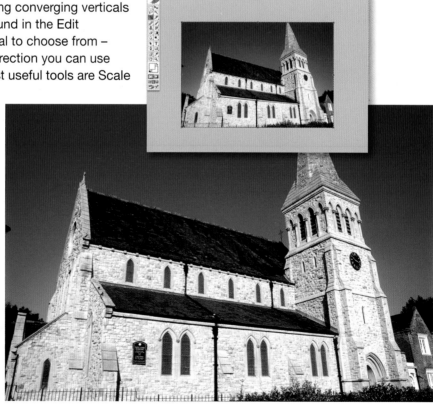

▲ Step 2

Carefully drag the top left and top right handles inwards so they are parallel to the verticals you want to straighten. In this particular shot the pillar on the left and windows on the right were used. If you are using a converging line further within the image to measure against, make sure you drag the bounding box crop area back to the edge of the image or you will lose everything outside the selected area.

▲ Step 3

When you are happy with the image, hit the Return/Enter key or click the arrow in the options bar. This technique works well with images that are not severely distorted. Use the bottom handles to correct distortion from shots taken when the camera was pointed down. Use the technique on the right for more difficult images.

The Transform tools

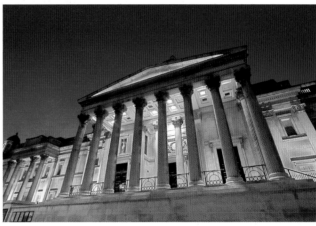

▲ Step 1

Here the Background layer is locked and you can't change the opacity, blend mode or layer order; the Transform tools will be greyed out, and in order to use them on an image you must unlock the Background layer so it becomes editable. Double-click the Background layer in the Layers palette. In the New Layer dialogue box type in a new name or leave it at the default 'Layer 0'.

▲ Step 2

Go to Edit > Transform > Perspective and a bounding box appears around the image with handles. It is best to make the image quite small and expand the document window to reveal the grey background so the handles can be moved more easily. Use the F key shortcut in Photoshop.

◀ Step 3

This is a difficult image to correct, but was chosen for this example to illustrate how you also need to use the Scale tool on some images. The perspective is now correct, but the building has lost its true shape. The beauty of the Transform tool is that you don't need to exit and re-choose the Scale tool – all the work can be done in one go. Here Transform > Scale was chosen. The handles now change to allow the image to be moved up rather than across.

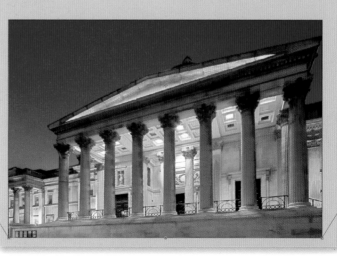

◀ Step 4

The building now begins to look normal after the top middle handle has been stretched upwards. You may need to redo this process several times to get a perfectly straight building. If you are having problems getting a straight line, View > Show > Grid applies a grid over the image. One particular problem is that correcting one vertical can mess another one up. This is usually because the image is not perfectly horizontal, as well as not being vertical. Use the Rotate tool to see whether this can correct the problem.

Making basic selections

Creating a basic selection allows you some degree of control over the image. Without making a selection, any effect that you apply is made to the whole picture; however, if you just want to change a specific part of the image, you need to select this area and apply the effect to the selection.

The Marquee tool

The Marquee tool allows quick and simple selections to be made. You can create rectangular or elliptical selections; the Rectangular Marquee tool creates a rectangular or square shape. Click on the icon to select it, and then drag from one corner to another. The selection starts with your first click and ends with your second. Once created, the selection can be dragged to any part of the image by clicking inside it. The Elliptical tool can be chosen for making oval shapes. Hold down the Shift key to constrain the shape to make a circle. Dragging makes the ellipse bigger, which is useful for correcting faces quickly.

Feathering selections

When you make a selection, the edge of the selection is a hard line. If you apply any effects to the selection, the transition between the selection and the areas outside it will be visible. To avoid this, you should use feathering to soften the edges and give a seamless transition between the altered area and the rest of the image. To feather a selection, go to Select > Feather and then enter a value in the Feather Radius box – a value of between 2 and 15 is normal for most selections.

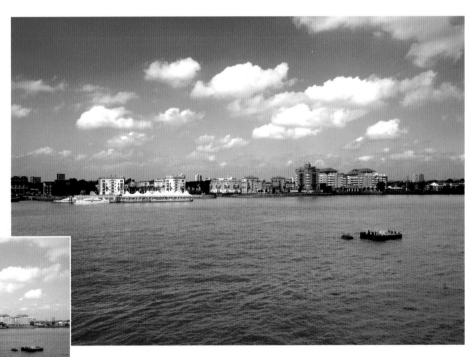

▲ *Altering a selection*
This is a classic example of a simple selection saving the day. The sky was overexposed (left), so a rectangular marquee was created over the entire sky and buildings. It is best to feather the selection slightly, by about 10 pixels, say, depending on how soft a transition you want. Levels was used to quickly darken the sky for a more natural and balanced look (above). You can go to Select > Inverse to invert the selection and alter the water if needed.

71

Layers

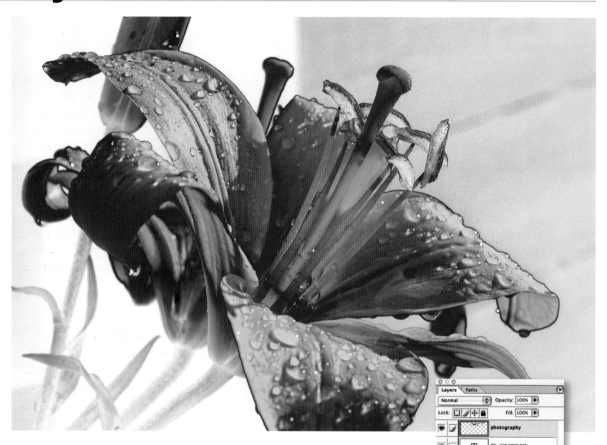

Layers are one of Photoshop's great strengths, and are also available in most other popular software applications. Layers allow you to create complex montages with ease, and can also be used for other creative jobs. Gone are the days of complicated, time-consuming and expensive lith masks; you can now paste all your elements together digitally – with no more scalpels or messy glue.

Layers let you add new elements to an image and allow you to edit them as often as you like. You can create all the usual effects, such as contrast or colour changes, and you can also move elements about, change the opacity or use blending modes to create some amazing effects. Adjustment layers even allow you to re-edit key commands such as Levels or Curves at any time during the project.

Think of layers as transparent sheets of acetate, like the ones used to create cartoons. You can paint little areas on each sheet, and when they are all laid on top of each other you can see all the painted areas as one image. You can take sheets out or add more or move them from top to bottom.

▲ ▶ *Layers explained*
The images here show how the different layers are positioned, how they look in the Layers palette and what the finished product looks like.

The Background layer

All new documents open with a Background layer. This is not fully editable, so you cannot move it or alter opacity unless you convert it to a normal layer. Double-click the Background layer and enter a name in the New Layer dialogue box.

Creating new layers

You can create a new empty layer by clicking the New Layer icon at the bottom of the Layers palette or using Layers > New in the Layer menu on the options bar.

Duplicating a layer

It is a good idea to get into the habit of duplicating the original Background layer so that if you make a mistake, you have the original to fall back on. Drag the layer to the New Layer icon at the bottom of the palette (not into the waste bin icon to the right!) or go to Layer > Duplicate

Layer. You can also import an entire layer, or a selection within the layer, from another document that is open on the desktop. Drag the active layer on to the new document, using the mouse and the Move tool, and a new layer is created automatically.

Deleting a layer

Go to Layer > Delete, or physically drag the layer to the waste bin icon in the bottom right of the Layers palette.

Moving a layer

You can drag a layer above or below another layer, except the Background layer, which is locked. Double-click and re-name the Background layer so it can also be moved.

Merging layers

In the Layers menu, Merge Down allows you to merge the active layer (coloured blue) with the one below it. Merge Visible merges all layers with an active eye icon, no matter where they are in the layer order.

Flatten merges all layers into one new Background layer; use this at the end of a project, remembering to choose Save As to keep the original layered document.

Saving layers

It makes good sense to save a master copy with all the layers still intact. This may take up space and memory on the computer, but it does allow you to make changes in the future; you may also be able to take parts from one image that can be used in another.

You should save in the native software format such as .PSD (Photoshop), .PSD (Elements), .PSP (Paint Shop Pro). Saving as a .JPG automatically compresses all layers into one.

Opacity

This is a very useful tool that allows you to alter the opacity of any layer that you choose. Use it to create stylish montages or to soften a filter/blend effect that is too strong. However, you cannot alter the opacity of the Background layer or another locked layer.

Visible eye

To make the layer invisible, turn the icon off by clicking it. Turning off the icon also de-activates the layer and you will be prompted to include it when merging or flattening layers.

Linking layers together

Next to the eye icon is the link icon, which allows you to group different layers together, no matter where they are within the Layers palette. You can use the Move tool to move all linked layers together as one, and you can also copy, paste, align, merge, transform or create clipping groups as well. The link icon is particularly useful for moving several type layers together when you want to maintain the same layout. You must remember to unlink layers if you want to make adjustments to just one layer.

Locking layers

These four symbols are positioned at the top of the palette and are used to protect the contents of a layer from manipulation.

Lock transparency
Allows you to confine editing to opaque (non-transparent) areas.

Lock image
Stops opaque areas from being edited with painting tools

Lock position
Stops the layer's pixels from being accidentally moved.

Lock all
Stops all editing on a layer when the dark solid lock icon is visible. When the lock icon appears semi-transparent on the screen, this allows you to perform some editing, but this depends on exactly what you have specified for working on.

Advanced layer options

There are many other things that can be done with layers: masking layers, blending modes, adjustment layers, text layers and style layers all play a vital role in creating quality images.

Layer masks
See page 100.

Adjustment layers
See page 90.

Text layers and style layers
See page 132.

Quick mask
See page 106.

Blending modes

This drop-down menu is found top left under the name 'Normal'. Click to reveal a list of blends that always interact with the layer below. You will need at least two layers for blending modes to interact.

Layer sets

These allow you to group and organize layers together and keep the Layers palette from getting too cluttered. Click on the 'Create a new set' icon at the bottom of the Layers palette. A small new folder appears in the Layers palette – to add it to that layer set, just drag any layer on to the folder icon. Each set can be colour-coded, which is useful, as you can group a series of layers together that create a particular effect. You then have only one eye icon to turn on or off to see the effect, rather than four or five.

Layers illustrated

In this illustration you can see the relationship between picture elements and where they are found in the Layers palette. Layer orders can be changed, apart from the Background, but you can make the elements in this layer become partially or fully obscured as they may go below another element, or you may alter a blend mode as it will interact with a different layer if moved.

The Layers palette is very complicated, but you should experiment with different settings using the same image to learn more quickly.

The red arrows show what clicking on the different icons does when applied to a layer. For example, the 'Create a new layer' icon brings up an identical duplicate copy of the Background layer and, above it, an empty new layer. Click on the top right arrow and the palette menu appears. 'Dock to Palette Well' will put the palette in the options bar where it can be easily accessed. The other commands can also be accessed via the drop-down Layers menu bar at the top of the screen.

▲ **The Layers palette**

The Layers palette is difficult to get to grips with but only by mastering it will you be able to design creative images such as the one above. Here the red arrows show how the different options are applied to the layers.

Blending modes

One of the most exciting group of effects can be found at the top of the Layers palette under the rather boring name of Normal. Click on it, and the blending mode menu appears as a long list of strange names. You can use blending modes elsewhere – for example, many painting tools can also be used with them. Blending modes allow one layer to interact with the layers below it to create a multitude of effects that combine pixels in different ways. The best way to learn about them is to try each one out. You will need a second layer similar to the first but altered in some way: try Gaussian Blur or inverting to a negative (Cmmd/Cntrl I) on one layer for some particularly nice effects.

◀ *In this example, the bottom layer has been turned into a negative, and the blending mode for the top layer has been turned to Difference. Black doesn't alter the base colour of the bottom layer at all, white inverts the base colour completely, and the in-between colours partially invert the colour, here shown back to the original yellow.*

Here, the inverted ▶ version of the lily was the starting point. A second layer was created, and a strong Gaussian Blur effect was added to the bottom Background layer. The top layer was then given a Linear Light blend – this has the effect of lightening colours lighter than 50 per cent or darkening colours darker than 50 per cent to give a more contrasted, graphic-style result.

In this ▶ image, the black background was first replaced with white. A second layer was created, and Gaussian Blur was then added to the Background layer as before. The top layer was then given a Darken blend; this produces a lovely effect, especially with black-and-white images.

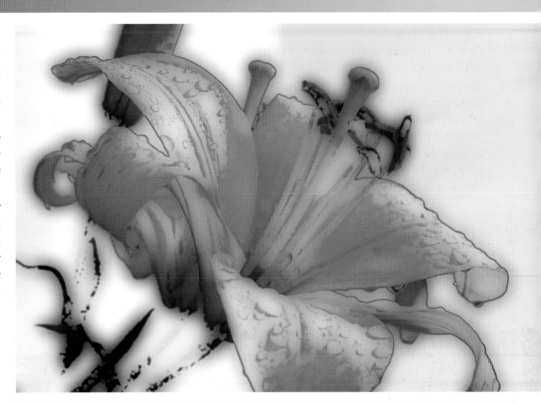

◀ The original colour layer was duplicated and inverted to create a colour negative. Gaussian Blur was then applied. The original colour Background layer was then made black and white. The Hardmix blend was then applied on the colour negative top layer. This produced a posterized effect that is very eye-catching.

▲ Here the original colour image was made black and white using Image > Desaturate, and a duplicate layer was created. The duplicate layer on top was inverted, and Gaussian Blur at a Radius of 25 pixels was used. The Color Dodge blending mode was then used to give a sketchy feel to the image. This was then flattened and another duplicate layer was created, and the Multiply blending mode was used to beef up the Beefeater.

Clone and Healing tools

These two very powerful tools are useful for removing dust, wires, rubbish, people and just about any other item that can ruin a shot. Once you get the hang of using image-editing software, the Clone Stamp and Healing Brush will be two of your best allies in retouching photographs. The basic principle is that you take information from an area that's unaffected and place it in the problem area. For this purpose there are two points: a cross hair that samples from a source point in the unaffected area, and a circle into which the information is painted. The size of the circle is dependent on the brush size.

Controlling cloning

There are three main controls to the Clone tool: Brush size/Hardness, Opacity, and Aligned or not Aligned. The brush in this tool has exactly the same attributes as the standard Brush tool.

*Clicking on Aligned makes the sampling point follow ▷
your circle in a parallel line. You need to hold down
the Alt/Option key and mouse click at the same time to
create a sampling point. The sample area is constantly
re-sampled as you move the brush around, as long as you
don't Alt/Option click again. Using this technique you can
clone entire objects perfectly, such as Big Ben as shown
in the example on the right. This is usually the best way
to use the Clone tool if you want realistic results, but it is
worth experimenting with cloning, depending on the type
of effect that you are trying to achieve.*

Clicking off ▶ Aligned in the options bar means that the sampling point remains the same all the time. Here the sampling point was the clock face, and this has been copied many times over.

Trade Tips: cloning

🖎 In Aligned mode, select a source point as close as you can to the mark. You should then be able to clone other blemished areas without creating a new source point. This speeds up the process.

🖎 If you are cloning a large area of similar tone, you may get a smudged soft effect that looks odd. To overcome this, select the area using the Lasso tool, feather 4 pixels and use Filter > Noise > Add Noise. Choose a very low Amount value. The Noise filter will camouflage the cloning.

Reducing the ▶ Opacity from 100% is useful only for subtle tonal work, for example on skin tones, where tonal transitions are very small.

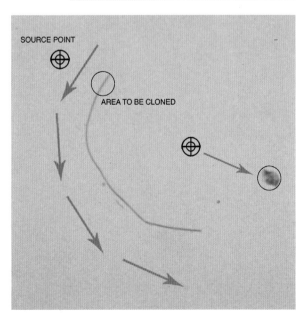

▲ *This example shows the difference between using a brush with a hardness of 100% (above) and 0% (below). The Hardness slider is found in the Brush tools drop-down menu.*

◀ *When cloning a line, create a source point at the top and then work your way down, following the shape of the line. It may be necessary to take several readings along the way, as colours can change between the start and finish points.*

The Healing Brush

Available only in Photoshop and Elements 3, the Healing Brush is similar to the Clone tool, but is in fact better for removing small areas, especially of skin tones. The Clone tool takes the source information and paints over the selected area, deleting all information under it.

The Healing Brush adds the underlying information and blends the two together, creating a much better final result. The tool's main weakness is that you can't heal areas of great contrast – using a light tone to remove a dark tone produces a grey tone, as it blends them together. This is very apparent at the boundary between two strong areas of colour or contrast.

The solution to this situation is to create a 2-pixel feathered selection at the boundary point so the brush can't use the information from the other colour.

▲ *A common problem with many digital photographs is removing blemishes at boundary edges. The Clone tool has done a good job, but it is not perfect.*

The Healing Brush has picked ▶ *up colour from the red flower and added it to the blend, creating an unacceptable finish. It would need several attempts to get the colour perfect.*

A selection was made of ▶ *the background along the edge of the flower, feathering it by 2 pixels to soften the hard edge. A source point was taken from the green background, and the Healing Brush was then passed over the blemish. As the colour contrast is quite pronounced in this particular image, it took four or five passes of the brush to remove the blemish completely. The final effect is a near-perfect blend with the blemish disappearing into the background.*

▶ Step 1

The tarmac path in this shot breaks up the composition. Using the Clone tool, choose a standard brush with a size of around 100 pixels and 100% opacity; you can lower the opacity for very fine tonal transitions. Tick the Aligned button so that the sampling point changes as you work along the path.

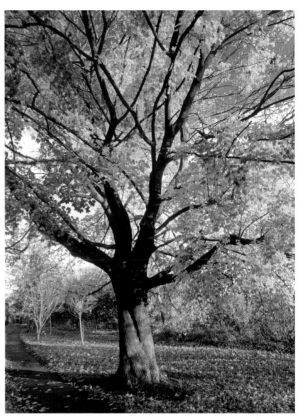

▲ Step 2

Here the cloning process has begun on the leaves to the right of the path. Use numerous sampling points when building up a large area like this, or repeat patterns can become obvious.

▲ ▶ Step 3

Once the bulk of the cloning has been done, you can remove any other distracting objects from the frame; here the signposts were removed. The final effect sees the tree surrounded by a carpet of leaves, which suits the shot.

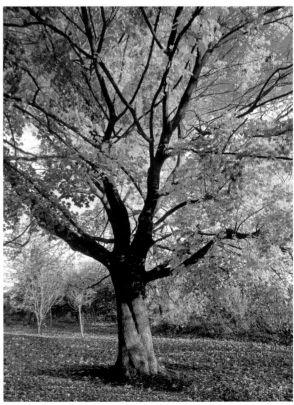

Filter effects

Most software packages come with a suite of filter effects. Filters allow you to create many amazing effects that it's not possible to achieve by normal manipulation. Adobe Photoshop and Elements come with the same suite, which contains dozens of very powerful filter effects, now grouped together in the Filter Gallery.

Another package worth mentioning is Corel's Painter 9, which allows you to re-create artistic media such as oil paints or watercolours. The quality of effects is excellent and well worth exploring at some stage. Filters can't rescue a lemon of a shot, but when applied tastefully to complement the image, they can work very well.

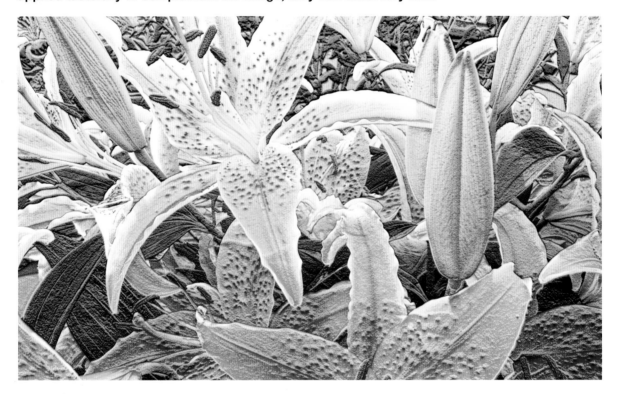

Using the Filter Gallery in Adobe Photoshop and Elements

A large preview box allows easy viewing of the effect applied. It also provides instant access to many filters, which are grouped in subsets called Artistic, Brush Strokes, Distort, Sketch, Stylize and Texture. The clever part is that you can apply several filters and those you have applied are saved in the Filter Gallery, so you can see a history of what you have done.

You can delete an effect, by dragging it to the waste bin, or rearrange the layer order, which can have a dramatic effect on the way the filters interact and how the final image looks.

First choose a filter, change the settings to suit your image, and then apply the filter. If you then reopen the Filter Gallery, the filter effect is stored in its memory as a layer and you can then apply another effect. Not all filter effects are available in the Filter Gallery, so check the main filter menu for others.

You can build up as many layers as you like and then use the eye icon to view the image with a particular filter turned on or off. One word of caution, however – you may not surface from the computer for days!

Testing filters

A lot of filters can be memory-hungry, and if you are applying a filter effect to a large image, this can take an annoyingly long time to finish, only for you to find out it wasn't what you were after. Some filter dialogue boxes have a preview, but not all.

There are two things you can do. First, create a small rectangular selection within the image and apply the effect to that: the time taken to filter is considerably less, and it is easy to undo the filter and try again with a different setting. Second, create a duplicate file and make it much smaller – try 100ppi instead of 300ppi. Filter effects such as Motion and Radial Blur (see page 118), where you have to guess the source point, can be tested and refined using the small file before you apply them to the bigger file.

The last filter setting is usually saved for use the next time you open up Photoshop, but it is best to have the hi-res version open on the desktop ready to be filtered. Buying extra RAM improves the performance of all software, including photo-editing packages, by making them work faster and improving overall performance. Filters just love RAM!

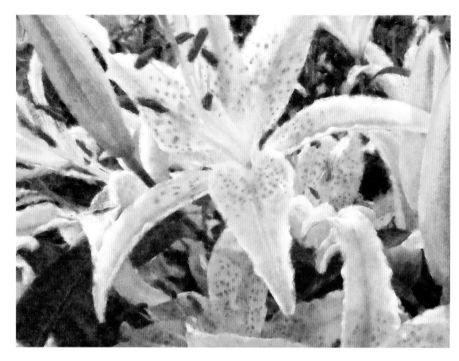

▲ *Clone filter*
This image was filtered using the Sumi Auto Clone in Painter 9. The Auto Clone does all the hard work for you and creates great effects in minutes.

▶ *Filter Gallery*
The dialogue box shows a large preview image and the filter choices are shown next to it. These thumbnails can be removed and the preview box can be made bigger by clicking on the small arrow at top right of the dialogue box. Each folder opens up to reveal a group of filters. The filter pop-up menu is on the right, along with any options for controlling the effect.

Controlling the effect

One excellent way of controlling the filter effect is to use the Edit > Fade command found in Photoshop, which allows you to fade the effect between 0% and 100%. You can adjust the blending mode in the same dialogue box at the same time. The other option is to create a new duplicate layer, apply the filter and then use the Opacity slider to control the strength of the effect.

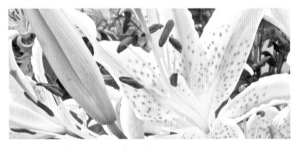

▲ Original

This is the original image before any filters were used. It gives an idea of the changes that have taken place after a filter has been applied.

Spatter ▶

This creates a paint-spray effect. In this example the Spray Radius was set to 20 and the Smoothness to 3.

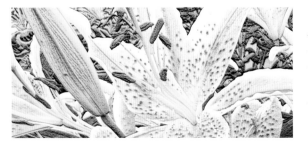

Third-party plug-ins

There are many third-party plug-ins available for most popular packages. Kai's Power Tools (now called Corel KPT Collection) is an excellent example of the interesting filters available. Most plug-ins reside in the Filter folder found in the plug-in folder. Extensis and Auto FX do a range of plug-ins, including Photo Frame and Photo/Graphic Edges, which add great edge effects to images, and Corel Knockout and Extensis Mask Pro allow sophisticated selections to be made. Plug-ins normally appear at the bottom of the Filter menu.

Popular plug-ins can be found on Adobe's website with appropriate links (www.adobe.com/products/plugins/photoshop/main.html).

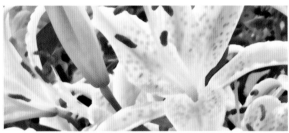

▲ Painter filter

Photoshop's version of the Sumi filter is markedly different to the Painter version. A Stroke Width of 3, Stroke Pressure of 1 and Contrast of 3 were chosen. Both versions are nice when viewed in isolation, but the Painter filter offers greater depth.

◀ Bas Relief filter

At this stage a copy layer was created and the Bas Relief filter was applied. A Detail setting of 12 and Smoothness of 3 were used, and Light came from the bottom. This was then merged with the colour layer to create the final effect.

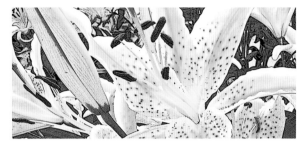

▲ Poster Edges filter

Poster Edges was applied with an Edge Thickness of 2, Intensity of 5 and Posterization 0. The effect is reminiscent of a line drawing filled in with watercolour.

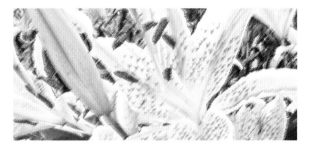

▲ Pastels filter

A strong effect was applied: Stroke Length was 11, Stroke Detail 10, Scaling 193%, Relief 50%, and Light came from the bottom. This produces a lovely pastel effect that looks great when blown up large. Image resolution alters the final filter effect – the larger the file size, the stronger the effect has to be to be seen.

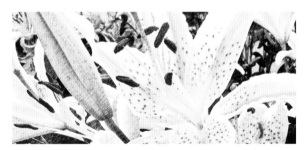

▲ Graphic Pen

When using the Sketch filters, put a black colour in the 'Set foreground color' box in the toolbox and white in the 'Set background color' box. These filters all work on the same principle. Here the Graphic Pen with a Stroke Length of 15, Light/Dark Balance of 51 and a Stroke Direction Right Diagonal was used. This produced a stark black-and-white image. Edit > Fade was then used, which brought up the Fade dialogue box. The Opacity slider was set to 70%, bringing back a faint hint of colour to produce a delicate effect.

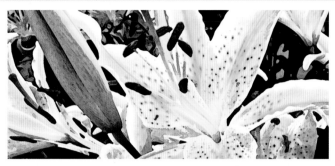

▲ Fresco

The Fresco filter produces a lovely effect like a graphic version of the Watercolour filter. Here a Brush Size of 8, Brush Detail of 3 and Texture of 2 were used.

▲ Gaussian Difference blend inverted

Here a copy layer of the original was created and Gaussian Blur was added at 23 pixels to give a very soft blurred image. The Difference blending mode was then used, which turned the layer almost black. Image > Adjustments > Invert was applied to this layer to create this day-glo pop-art-style image.

▲ Solarize

Click through Filter > Stylize > Solarize to produce a very dark image that tries to recreate the effect of solarization obtained by exposing a traditional C-41 colour print to light. This was always a hit-and-miss affair, and the filter does a reasonable job of recreating the effect. You can then use Curves (or Levels) to brighten the image and increase the contrast.

85

Replacing a sky

How often has a lovely scene been ruined by a boring sky? The worst offenders are grey, overcast skies that kill the impact of a picture. With digital images it is easy to replace the sky – or, indeed, any element you wish – to improve the overall effect. Be on the lookout for new skies and other backgrounds that can be swapped when needed.

Create a specific folder to hold all your skies and backgrounds for easy reference, and build up a selection shot at different times of the day and year and in different light conditions. This will allow you to match skies to foregrounds accurately when making replacements.

◀ Step 1

Open the picture. Select the sky with the Magic Wand tool. You may need to tweak the Tolerance level so that the Wand picks up the right pixels – those of the sky and nothing else. The higher the Tolerance, the more colours are picked: in this example, a Tolerance level of 32 was used. Click on Contiguous to maintain more control of where the Magic Wand looks. Hold down the Shift key to add more areas to the selection.

◀ Step 3

It is best to feather a selection to soften the edges, so the cutout doesn't look fake; 1 pixel should be enough. Go to Select > Feather and enter the number of pixels you want to feather the selection by, then hit OK. If you have just spent a lot of time and effort creating a complicated selection, go to Select > Save Selection to store it as an alpha channel for future use. In the dialogue box call the selection by an appropriate name. Save the file as a .PSD or .TIF – saving it as a .JPG compresses the data and you will lose alpha channels.

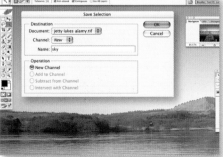

Step 2

After four or five clicks you will be left with only small areas to add. Zoom in using the magnifying glass or with the keyboard shortcut Cmmd/Cntl + to check that all areas are fully selected.

◀ Step 4

It is now time to remove the old sky by going to Edit > Clear. Make sure that you have turned the Background layer into an editable one first by double clicking on the layer in the layers palette and re-naming it. Now open the new sky image so that it can be pasted across into the main picture. With both images open, click on the new sky image to make it the active window, then click on the Move tool and drag the new sky across to the other window. The new sky will automatically be pasted into a new layer above the other layers in the original image.

◀ Step 5

It is possible to size both images so that the width and resolution are the same, but in practice it is easier to resize the sky using Edit > Transform > Scale. Remember that quality will suffer if you paste in a sky that is drastically lower in resolution than the main image. Place the sky in the top left corner and drag the bottom right handle; hold down the Shift key to constrain proportions. If it still doesn't fit exactly, drag the appropriate handle without the Shift key held down. Too much free transforming can distort the proportions, so use this with care. In the case illustrated here, the bottom handle had to be dragged down 2.5cm (1in).

▼ Step 6

To finish the job, drag the sky layer (Layer 1) under Layer 0 so that the tops of the hills can be seen. To do this, simply drag the layer in the Layers palette.

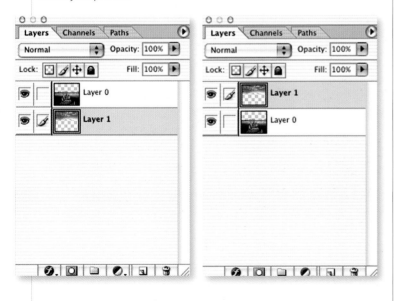

Trade tips

🖎 Always check the image size and resolution of the new sky or element before you bring it into the image. If the resolution is significantly lower, it will be clearly visible and won't fool anyone.

🖎 Don't transform an item out of proportion too much – always hold down the Shift key and transform it proportionally as far as possible, otherwise the new element will almost certainly appear distorted and unnatural.

🖎 Make sure you use a new sky that is going to look believable in the end result. Look at the tones and the way the light is falling in both images, and try to find a convincing match.

🖎 Take extra time over complicated selections, as the more accurate they are, the better your final picture will look.

Creating sunsets

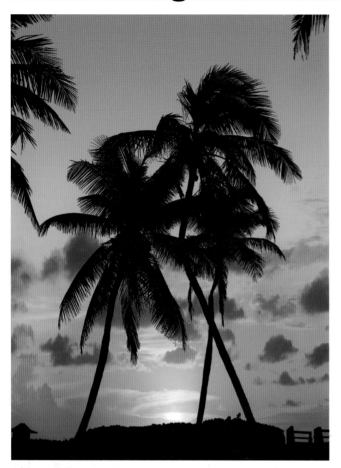

Step 1

On the sunset picture, use the Eyedropper tool to select a light orange from the middle of the sky; the 'Set foreground color' box shows the colour you choose. Clicking the 'Switch colors' icon to the right of the boxes allows you to flip the colour boxes. Next, select a darker orange from the top of the sky. Always try to use colours from your original image where possible for a more authentic colour feel, but use the Swatches palette if you want to create a colour that is not available from within the actual image.

The Gradient tool can create two types of fill that are particularly useful. The first of these is a Foreground to Transparent fill, which acts rather like a graduated filter that you would use on your camera. This creates a solid colour that fades to transparent, so, for example, a blue gradient fill can be added to enliven and brighten up a bland grey sky without affecting the rest of the picture. The second, as used in the step-by-step example shown on these pages, is the creation of a two-colour (or more) solid fill using the Foreground to Background style. Both of these techniques are also useful for creating backgrounds for postcards or other designs, which you can then overlay with photographs and text.

Step 2

Select the area of the image that you want to fill with the gradient, using the Lasso tool or the Magic Wand. If you don't make a selection, the gradient fills the entire page and covers up your image. Now feather the selection to create a seamless transition in colour. You can place the gradient fill directly on to the main image, but it is best to create a new layer, as this allows you much greater control of the gradient.

Step 3

Choose the Gradient tool. Click on the gradient sample at top left in the options bar to open the dialogue box with all the different gradient styles. You can alter the colour, contrast, tonality and transparency so fine adjustments can be made; you can also use the blending modes to create special effects. In this example, only the first two were used – Foreground to Background and Foreground to Transparent, as the others are a little gimmicky.

To draw the gradient on to your image, drag the mouse from the top to the bottom of the selection. A line appears, showing you the extent of the gradient. Hold down the Shift key to keep the line straight. You can drag the line at any angle if needed, and you can alter the transparency of the gradient in the options bar. After filling the gradient, you may get streaks in it; use a small amount of Noise (Filter > Noise > Add Noise) – around 1–3% should be enough to make these disappear. Remember to keep the selection active so that you don't add unwanted noise.

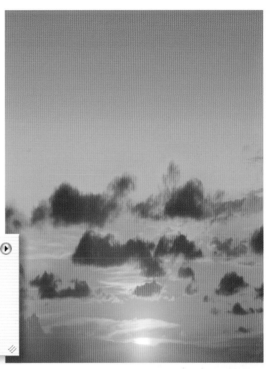

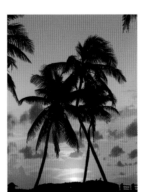

◀ Step 4 ▶

The image now needs some foreground interest, following the techniques covered on page 86. The background sky in this image was selected and removed, leaving just the silhouettes. Remember to feather the selection so that the edges are soft and the trees don't look as if they have been cut out with a pair of blunt scissors.

◀ Step 5

Using the Move tool, now drag the sunset into the new image so that it lies over that new image, and let go. A new layer is automatically created.

To finish the image, you may need to put the sunset layer behind the trees layer by switching the two on the Layers palette.

Adding rays of light

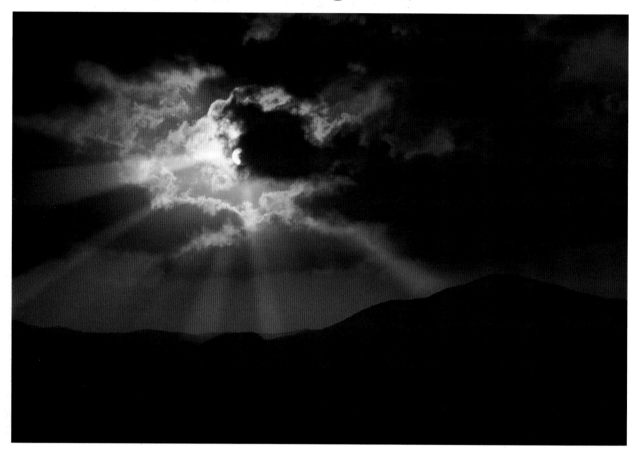

Moody sunsets can often benefit from a few rays of light to give them that dramatic finishing touch. The most controllable way of achieving this is by using adjustment layers. Instead of working directly on the Background layer, which means that you get only one stab at the job, you can create individual layers that can be altered at any point during the process. If you decide something is too dark or light, the adjustment layer can be activated and reworked. This is a powerful tool that is very useful when working on a complicated image, which may evolve and change markedly from the original concept.

What is an adjustment layer?

An adjustment layer is a mask that has been saved as an alpha channel in the Channels palette. You can create a selection using one of the selection tools, or by using a Quick Mask that has been turned into a selection, or you can manipulate the entire layer. This group of special layer masks allows you to adjust the tone, colour and contrast using the commands available from the Image > Adjustments menu.

Adjustment layers are stored in the Channels palette as alpha channels as standard grayscale masks. These are generally black and white, with grey parts showing semi-transparent areas.

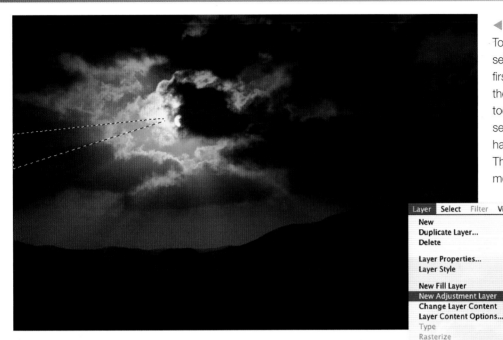

◀ Step 1

To begin, make a selection for your first ray of light using the Polygonal Lasso tool. Feather the selection to ensure it has a smooth edge. This will make it look more believable.

Step 2 ▶

Choose the icon at the bottom of the Layers palette, or go to the menu and choose Layer > New Adjustment Layer > Levels. At this point you have a choice of the type of adjustment layer you want. Here, Levels was chosen to adjust the brightness of the ray of light. A dialogue box now appears, asking you to name the new adjustment layer; you can give this any name you like but the default 'Levels 1' is as good a name as any.

▲ Step 3

A standard Levels dialogue box then automatically opens. Increase the brightness in the usual way, using the Input Levels sliders, and also increase the overall lightness by increasing the Output Levels slider until you are happy with the effect.

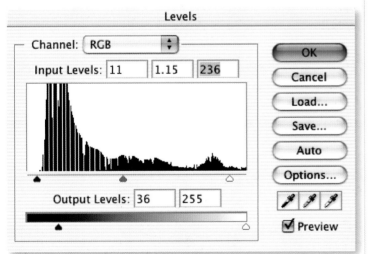

◀ Step 4

This process can be repeated until you have a number of different rays on several different adjustment layers – here there are five. You can now adjust the brightness and contrast of each ray to create a more realistic impression – if they all looked exactly the same, the image would appear false.

Changing an image from colour to black and white

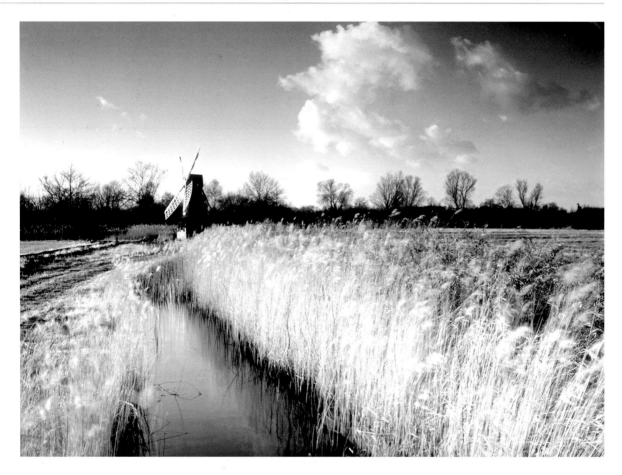

Shooting in black and white has always been popular. A black-and-white photo creates a totally different mood; it can add an air of mystery and put more emphasis on the subject of a shot. The days of going into a darkroom and messing about with chemicals are fading rapidly; we can now sit comfortably at a computer and alter images with ease.

Grayscale

Some older digital cameras allow you to take and save grayscale images. This can save a lot of space on your memory card, as a grayscale image has only one channel, as opposed to a colour image's three channels, Red, Green and Blue. The disadvantages are that the images are not always of a good quality, and enlarging grayscale images can cause tonal banding known as posterization. If you change your mind later and want colour, you have to go back and re-shoot. Most modern digital cameras don't have a grayscale mode for this very reason. Shooting in colour gives the option of converting to black and white later.

Different conversion methods

There are several methods for converting colour to mono. Some are better than others.

Original colour image.

Desaturated image – lacking in contrast.

Converted to grayscale – better tone and contrast.

The three shots above show that reducing saturation using Image > Adjustments > Desaturate is not the best method for creating a black-and-white image: the colours don't convert well, and contrast is very poor, especially with greens and yellows. Image > Mode > Grayscale produces a far better result – the tones are more realistic, and contrast is better. From this point you can select areas for further tonal adjustment using Levels or Curves. To add a colour tint to grayscale images, convert them back to RGB mode: go to Image > Mode > RGB Color.

Channel Mixer

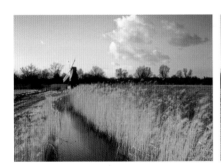

Original colour image.

Grayscale image – lacking in tonal variation.

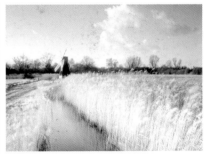

Red channel – adjusted for better tonal variation.

In this series the conversion is taken one step further, using Image > Adjustments > Channel Mixer. The grayscale conversion is reasonable, but Channel Mixer allows you to mix up the colour channels to create more interesting tonal variations. The Monochrome box should be ticked to change the image to grayscale – this also changes the Output Channel to Gray. There are three sliders representing the three colour channels, Red, Green and Blue. The default is +100% Red Channel, which already has a higher contrast look to it.

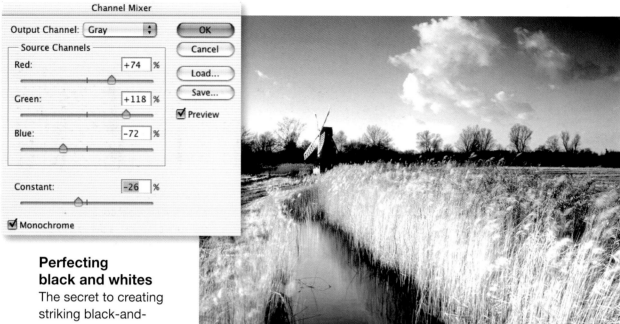

Channel Mixer

Output Channel: Gray

Source Channels

Red: +74 %

Green: +118 %

Blue: -72 %

Constant: -26 %

☑ Monochrome

OK
Cancel
Load...
Save...
☑ Preview

Perfecting black and whites

The secret to creating striking black-and-white images is to try to keep the Channel Mixer settings as close to 100% as possible, so this requires a little mathematics. In this very moody and contrasty version, Red is +74%, Green is +118% and Blue is -72%. The Constant determines how much white or black is maintained. In this case, reducing the Constant has darkened the image. The best way to learn and understand is to experiment with the settings and look at the effects that different combinations produce.

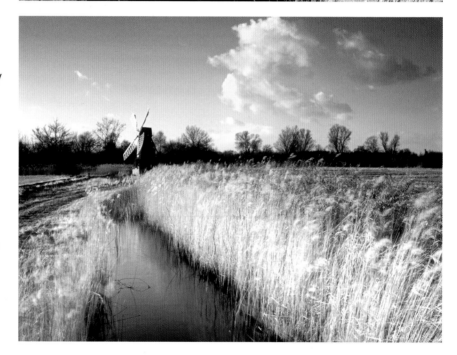

Adding tints

Once the image has been altered using the Channel Mixer, you can add a colour tint. Open the Hue/Saturation dialogue box and tick the Colorize box to turn the image into a tinted monotone image. To change the default red tint, specify a colour from the colour swatch first or just use the sliders. For this traditional sepia-toned example, the default setting was changed to Hue +27 and Saturation +32.

Colour channels

Red channel
The Red channel contains most of the highlights and can be easily manipulated.

Green channel
The Green channel contains more of the midtones and can also be edited successfully.

Blue channel
The Blue channel contains all the shadows and is the least able to be manipulated.

In a grayscale image converted to RGB, the three channels can be separated out into their individual channels. It is these three channels that are used by the Channel Mixer, and they are the default starting point for each channel when the Monochrome box is ticked. It is really only the Red and Green channels that can be utilized for tonal changes. The Blue channel is usually the least receptive to changes, so should be ignored. The idea is similar to the technique of using a coloured filter over the lens when shooting on black-and-white film.

Creating colours

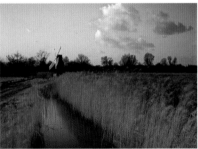

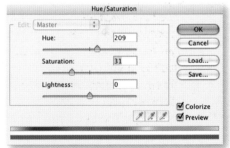

Red hue
The Hue slider was set to 11 by moving it all the way over to the left. The Saturation slider was left alone for a subtle effect.

Blue hue
The Hue slider was changed to 209 to create this blue effect. The Saturation slider was increased slightly to boost the colour.

Hue/Saturation dialogue box
The Colorize box is found bottom right and needs to be ticked to go into Colorize mode. Click Preview to see changes applied.

These variations show how easy it is to create a whole range of different colours to tone black-and-white images. The screengrab shows a typical setting, in this case to create a blue tint. Tick the Colorize box first. The Hue slider alters the colour, and the Saturation changes the strength of colour.

Making complex selections

Selections are an essential way of allowing changes to be made to part of an image. They allow you to select from broad areas, such as skies, down to much smaller areas of detail; as long as the selection remains active, you can apply as many effects to it as you wish. Mastering selections is an essential part of getting the most out of Photoshop or any other image-editing package.

Lasso, Polygonal Lasso and Magnetic Lasso tools

These commonly used tools are quick, easy and accurate. The **Lasso tool** allows you to create a freehand line, drawing around any shape you choose. Click to begin and then drag the mouse or pen around the shape and join it up at the beginning again. An outline of 'marching ants' is then created. Its accuracy is dependent on your own drawing skills, and for this reason a pen and graphics tablet (see page 17) make this and many other jobs easier and more accurate.

The **Polygonal Lasso tool** allows you to draw straight lines around a selection. You can also use the points to select a difficult shape. This is a good way of working if you have not fully mastered your freehand skills.

The **Magnetic Lasso tool** automatically finds the edge between two defined areas. It works well only if the two edges are high-contrast, otherwise it does tend to hunt a lot. You may find that your photographs don't have such well-defined edges, so you may rarely use the Magnetic Lasso tool; however, there are likely to be times when it is needed.

Magic Wand tool

Another great tool is the Magic Wand, which can be used to select very complicated areas of similar colour in a few clicks. Choosing the right settings is crucial to getting the best from this tool; making the Tolerance setting higher makes Photoshop look for more colours similar to the one you chose – if it is too high you will get colours being selected that you don't want. It is best to use a fairly small Tolerance setting of 35–50 and then use the Shift key to add more areas. Select Contiguous to keep the selection area small; de-select it if the colour you want appears in patches all over the image.

With a low ▷ Tolerance setting of 10 pixels, the Magic Wand picked only a small area of the reds. This is because the reds go from dark to light and cover a wide tonal band.

With a Tolerance ▷ setting of 50, a lot more red has been picked. Hold down the Shift key and click to select the entire poppy. Clicking on the black centre also selects other blacks outside the poppy; select Contiguous to restrict the search to a smaller area. Use the Lasso tool to quickly tidy up small areas.

The final ▷ selection, after clicking about six times on the reds and blacks, was then feathered by 2 pixels.

Pen tool

The Pen tool allows you to create a path using anchor points. It works in a similar way to the Polygonal Lasso tool. You can add as many or few points as you like; the Pen tool allows you to edit the points afterwards, so precise shapes can be drawn. You can then go to the Paths palette and click on the 'Load path as a selection' icon to convert the path to a working selection. This is particularly useful for creating selections with the mouse. Make sure you click the Paths icon in the options bar before starting.

Feathering selections

Select > Feather allows you to soften the edge of a selection. You should always feather a selection, as it stops the effect you are applying from sticking out like a sore thumb. A very subtle Radius value of 1–5 is often enough for fine detail, but a much higher value of 100–150 is often necessary to create very soft blends when creating changes in an area of flat tone, such as a blue sky.

Feathering ▷ Here, the top flower has no feathering, the middle flower has a radius of 3 pixels, and the bottom one a radius of 15 pixels. The more you feather, the softer the edge and the greater the vignette.

Adding and subtracting from a selection

The main way to alter a selection is to add or subtract areas once the initial selection has been made. The Shift key is used to add to a selection, and the Alt/Option key allows you to remove areas from a selection; hold down the appropriate key before making the alteration. If you forget to do this, your original selection will disappear, but don't panic – Cmmd/Cntrl Z will bring it back. If you have already feathered the selection and wish to alter it, remember to add the same value in the Feather options bar, or the new sections will have a different edge. Also try the Quick Mask mode for creating soft and hard edge effects on a selection.

Changing selections

You can invert a selection by going to Select > Inverse. This is useful, as you can often use the selection twice: for example, select the sky, alter it and then invert the selection to alter the land. Use Select > Modify > Expand or Contract to fine-tune the selection by a few pixels. Once you have applied a solid or gradient fill you can also use Filter > Other > Minimum to expand the entire fill by one or more pixels.

Moving and pasting selections

The simplest way to move a selection is to drag it using the Move tool. Holding down the Alt/Option key before dragging will create a new copy that can then be moved. When you are happy, de-select.

A much more controllable method is to copy the selection to a new layer. With the selection created, go to Edit > Copy and then Edit > Paste. This automatically places the selection in a new layer. Once in a layer, the selection can be repositioned at any time. You can also create a selection in another document and move it, by dragging with the mouse or clicking Edit > Copy (Cmmd/Cntrl C), then clicking on the new document to make it active and clicking Edit > Paste (Cmmd/Cntrl V). Hold down the Shift key when dragging to keep the image centred.

The accuracy of your selection depends on the final use. If the two backgrounds are similar you can get away with a loose selection, but more care is needed if placing the selected element on a different background.

Saving selections as alpha channels

Selections are temporary masks and disappear when de-selected; for this reason, it is best to save any selections that you have taken time over creating, as having to redraw them is highly frustrating and extremely time-consuming. With the selection on screen go to Select > Save Selection to save it. In the dialogue box give a name to each selection you save. You can save your selection as you go along, and in the dialogue box choose Add to Channel as it progresses. When selections are saved they are stored in the Channels palette as an alpha channel, which is a grayscale representation of your selection – saved selections will be lost if saved as a JPEG or GIF file. To reload a saved selection, go to Select > Load Selection and choose the appropriate selection to load.

Selecting a colour range

Color Range is a very useful and powerful selection tool that can save a lot of time. It is especially useful for areas that have complicated detail, such as trees against the sky. Go to Select > Color Range. Clicking on a colour picks it across the entire picture. Use the Fuzziness slider to alter the tolerance quickly and easily. The higher the Fuzziness slider, the more similar adjacent colours are selected.

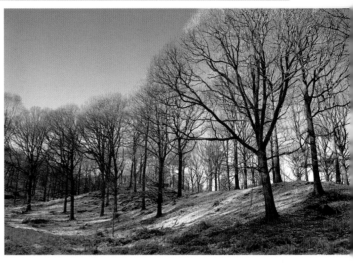

Step 2

After you click OK, a selection of marching ants is created. It is often best to feather the selection. You can also fine-tune the mask by going into Quick Mask.

Step 1

Selection Preview allows you several options for previewing – Grayscale is best for most jobs, as it changes the entire image to grayscale tones. You can easily add or subtract using the + and - eyedroppers to alter the selected colours. This creates a grayscale mask with subtle transparency. As you can see, here it has produced a very complicated mask very quickly.

▶ **Step 3**

The reason for creating the mask was to add a more colourful blue sky in place of the rather insipid one. A blue colour was selected from the swatches, and the

Gradient tool was used at 50% Opacity to add the blue. First, a new layer was created to control the opacity, then the blending mode was set to Darken. This merges the gradient with the layer below to create a more subtle effect.

Layer masks

Layer masking is another powerful tool available in Photoshop. It allows you to make adjustments to a layer using the Brush tool, which can be altered or even removed entirely. Just like adjustment layers or Quick Mask, it uses an alpha channel to store a mask, which is editable at any time during the project or even long after it has finished, as long as you save it in the native Photoshop format (.PSD).

You must have two layers to make this work, and they must be different or you won't notice any changes happening. Click on the 'Add layer mask' icon at the bottom of the Layers palette. A white box and mask icon appear in the layer you have active. You *must* click on the white box to activate the mask to allow you to paint with the brush. The 'Set foreground/ background color' icons in the toolbox change to the default black-and-white colours. Imagine that the mask is totally opaque to start with – painting with black will create a hole in the mask to reveal the layer below, while painting with white will repair the mask back to its original opaque state.

This allows you to add or remove from the mask at will. By changing the opacity in the options bar you get a semi-transparent mask. You can completely remove the layer mask at any time by going to Layer > Remove Layer Mask > Discard, or by dragging the icon to the Layers waste bin.

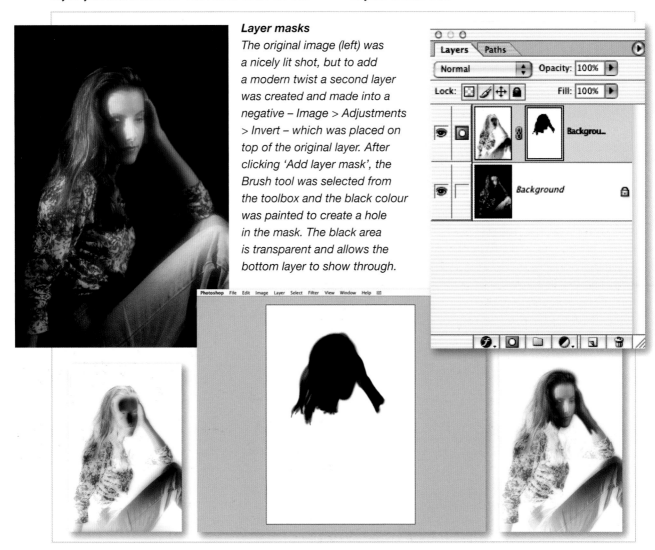

Layer masks

The original image (left) was a nicely lit shot, but to add a modern twist a second layer was created and made into a negative – Image > Adjustments > Invert – which was placed on top of the original layer. After clicking 'Add layer mask', the Brush tool was selected from the toolbox and the black colour was painted to create a hole in the mask. The black area is transparent and allows the bottom layer to show through.

Selecting around hair for a realistic look

One of the most difficult and demanding jobs is selecting around hair – if you can master this, you can tackle just about any selection job. There are several ways of achieving it, including third-party plug-ins such as Corel's Knock Out or Photoshop's Extract filter, but the method here can be used by most packages.

◀ Step 1

For a complicated selection around hair or fur, try using the Quick Mask mode in Photoshop (see page 106). First, roughly select the subject, in this case the cheetah, using the Lasso tool. Then click on the Quick Mask icon at the bottom of the toolbox. This turns the selection into a red mask.

◀ Step 2

Using a small brush size of around 25 pixels and an opacity of 100%, carefully go around the edges and add any fur not already within the mask area. Then use a bigger brush of 60 pixels and an opacity of 50% to add extra areas just beyond the mask edge. This soft transition border stops it looking like a cardboard cutout.

▲ Step 3

Once you are satisfied, click the Edit in Standard Mode icon (Cmmd/Cntrl Q) to turn it back into an editable selection. Edit > Copy and then Edit > Paste places the new cutout selection on its own layer.

▲ Step 4

The final stage is to paste the cheetah into an image of an African impala buck shot in the Kruger Park, South Africa. The cheetah is resized using the Transform tool, and the impala is given some Gaussian Blur to create an out-of-focus telephoto effect.

Blurring backgrounds

Blurring backgrounds has several advantages. You can mimic the shallow depth of field a camera has when using a large aperture on a telephoto lens; the blurred background makes the subject stand out and puts greater emphasis on it. Blurring the background also removes annoying distractions, which can lead the eye away from the subject, and resolves the problem of shooting against an inappropriate background that does not suit the subject, or one that is cluttered with people.

The Blur tool
The Blur tool can be found in the toolbox along with the Sharpen and Smudge tools. It acts like a brush, and you can use it to blur small areas with great control. You can alter the strength and brush size in the options bar.

Original image ▶
In the original shot the background is cluttered and distracts from the main subject. It would be impossible to correct this in-camera without moving all the people.

The Blur filters

Go to Filter > Blur to see a variety of different blur filters. To create a general fuzzy blurred background, Gaussian Blur is the ideal choice (see page 117).

Before you use any of the blur filters, you must first select the area you want to blur, otherwise you will blur the entire image.

Once you have selected and blurred the background, the foreground subject may appear too sharp. You can always add a small amount of Gaussian Blur to this subject as well, so that it is slightly softened against the background.

Making a selection using the Pen tool ▷
The Pen tool is found in the toolbox, and can be used to select the background. You can create as many anchor points as are needed. For curves you need a lot of anchor points, but straight lines can be anchored by just two. As with a normal selection, start at one end, work your way around the background and join up back at the beginning. What you end up with is known as a path. You must now convert this to a selection to work on it. Go to the Paths palette and click on the 'Load path as a selection' icon at the bottom of the palette. The path is now transformed into the typical marching ants of a normal selection. Save the selection if required. This is a great tool for selecting complicated shapes.

▲ *Tidying up the selection with the Lasso tool*
The Pen tool cannot capture all the fine detail, so you may want to use the Lasso tool to tidy up the selection. With the background now fully selected, feather it by a few pixels for a soft edge. This will add to the effect.

Combining colour and black and white in one image

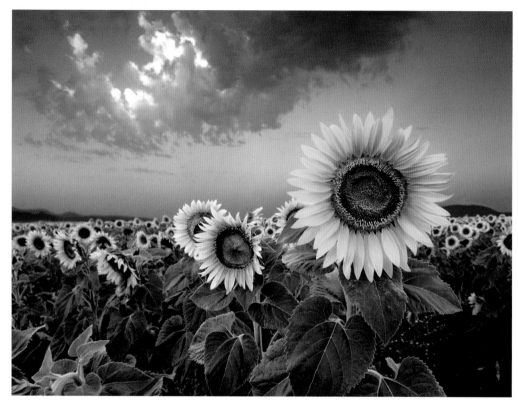

It is possible to create great effects with image-editing software. Using traditional methods, combining black and white and colour in one image would be a very difficult and time-consuming, if not impossible, procedure. Using selections and masks, it is possible to build up a complex selection quickly and easily.

◀ Step 1

To begin, copy the original image using the Save As command and re-name it Grayscale. Convert the image from RGB to grayscale using Image > Mode, and then back to RGB using the same method; this is the best method for accurately converting colours to black and white (see page 93). You need to convert it back to RGB to add it to the colour sunflower image, as you can't have an image that has a grayscale and RGB layer at the same time. With the two images open, select the Move tool and drag the grayscale image to the colour one while holding down the Shift key, which makes both images automatically line up over each other in perfect registration. Rename the colour Background layer and place the grayscale layer underneath.

▲ Step 2

Using the Lasso tool, go carefully around the edge of the subject that will be colour; here, the prominent flower in the foreground provides maximum impact. Don't worry too much if the initial selection is not perfect – it is possible to go around it again and fine-tune: still using the Lasso tool, add or remove areas to the initial selection. Use the Shift key to add and the Alt/Option key to remove.

▲ Step 2 alternative

An alternative to using the Lasso tool for fine and intricate work is the Quick Mask tool. With the selection active, click on the small icon at the bottom of the toolbox or use the keyboard shortcut Q. The selection is converted into a red mask – this is its default colour, which can be changed using Preferences if it clashes with your subject colour. In the example, the mask colour has been left as the default red.

Select a small soft brush from the palette and use the black colour to add to the mask and white to remove. A very accurate mask can be quickly built up in this way.

Hit the Q key to return to a normal selection. Feather it by at least 1 pixel to soften the edges. Make sure you remember to save it by going to Select > Save Selection so you don't lose your valuable work.

◀ Step 3

Next, invert the selection so that everything except what was initially selected is now selected. To do this go to Select > Inverse. Then click Edit > Clear to remove the background. This will reveal the black-and-white 'Grayscale' layer underneath.

◀ Step 4 ▶

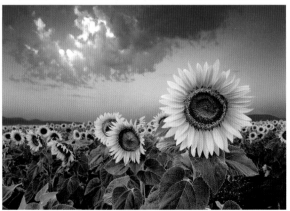

This shows the final layers of the finished image. As a variation you can reverse the selection so that only the main subject becomes black and white.

Quick Mask mode

A selection can be saved (Select > Save Selection) and stored as an alpha channel in the Channels palette. You can also turn the selection into a Quick Mask so you can alter it using the Brush tool to create more subtle transitions in transparency or alter parts of the selection with greater control than with the Lasso tool. Selections and masks are one and the same: a selection is a temporary mask that disappears unless it is saved, in which case it becomes a permanent alpha channel mask.

Quick Mask mode allows you to create a mask either from scratch or, more commonly, from an existing selection. Click on the Quick Mask icon at the bottom of the toolbox, or press Q to enter and leave the mode. A red semi-transparent colour, similar to the old rubylith film used by repro studios, appears in place of your selection.

If you are working on a red object, you can change the mask colour. Double click the Quick Mask icon and alter the colour and opacity to your own taste. The red mask area surrounds your selection and covers the parts of the image that won't be altered. The red colour makes it easier to see the mask, but the mask is in grayscale mode and is actually black and white with shades of grey. 'Set foreground/background color' goes black and white, and you can use the Brush tool to add or subtract from the mask. Use black to add to the red mask (areas outside your selection that won't be altered) and white to subtract areas from the red mask. The Opacity slider offers any shade of grey in between black and white, represented by a lighter shade of red on the mask.

▲ *Red mask*
Although the mask appears in red on the image, in reality it is in grayscale mode and is black and white.

▲ *Quick Mask mode*
This is how the alpha channel displays in Quick Mask mode. You can change the red colour to one of your own choice as required.

◀ *Channels display*
The Quick Mask or selection resides in the Channels palette as an alpha channel if you save it. Alpha channels are simply a way of storing selections and masks as information. Alpha channels can be copied from one document to another, so if you create a special effect frame edge mask you can save it and use it on any other image you choose. To copy it across, simply drag it across from one document to another, as though you were copying any other layer.

80% Gradient fill at the top

30% Gradient fill at the bottom

▲ Step 1

The original image was overexposed. A Quick Mask was created that would darken the sky a lot and the land a little. I used the Gradient tool, which is very useful for creating soft mask transitions. They have many applications, such as tonal or contrast control and applying special effects and filters to certain areas.

> **Trade Tip**
>
> 📷 Selections created with the Lasso tool or Gradient Quick Mask are only temporary selections. To store and save them as permanent masks you must go Select > Save Selection, which saves the selection/mask as a permanent alpha channel. This will still be there if the document is closed and then opened again. Go to Select > Load Selection and choose the relevant one.

▲ Step 2

The secret was to create a double mask as one. You must first activate the Quick Mask mode by clicking on its icon in the toolbox. The opacity in the Gradient options bar at the top was set to 80% and I dragged the mouse from the top to about halfway – use the Shift key while dragging to maintain a straight line. I then changed the opacity to 30% and did the same but at the bottom. This created two distinct gradations which, when applied, darkened the sky a lot more than the land. It is, of course, possible to correct each area separately, but this method is quicker and easier.

Adding text using the Quick Mask mode

You can also create text effects using the Quick Mask mode. Select the Text tool and then go into Quick Mask mode. When you start typing, the document goes red and the type is white. Click on the Move tool and then return to Standard mode, which is next to the Quick Mask button. The type outline will be selected and you can now go to Select > Save Selection to create a mask. Now you have the type selected you can do as you please: add a colour, use Levels to darken or lighten it, invert it or filter it.

Here the ▶ *image was inverted to a negative, and the Ink Outline filter and then the Solarize filter were used on the text.*

▲ *Here the text selection was changed using Filter > Texture > Stained Glass. I then inverted the filter colours using Image > Adjustments > Invert.*

107

Changing an object's colour

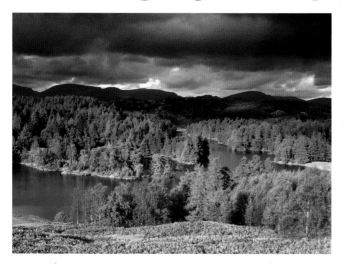

There are occasions when you may want to change a colour within a scene – you may want to alter the colour of a piece of clothing or even see what a car might look like in different colours. It is possible to change one colour without selecting it by using Image > Adjustments > Replace Color or Hue/Saturation, both of which allow one colour to be chosen and changed. For more intricate jobs you may need to create a selection around the colour you want to change.

The impact of colour

We have already seen how colour can dramatically affect the mood of a photograph; using image-editing software, you can change colours at will and create as many different variations of the same picture as you want.

The example here and opposite uses a highly graphic image to show the impact of changing the colour of an element within a scene. Commercial photographers often use similar techniques to change the colour of a product or clothing, or to alter a background.

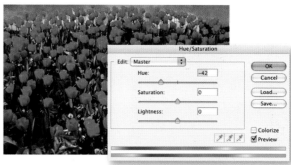

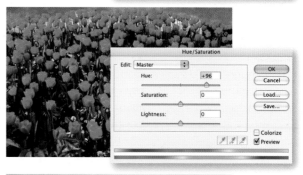

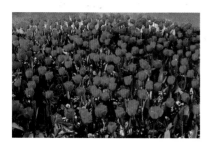

Altering a single colour

In this example, the red tulips were selected using the Magic Wand and feathered by 1 pixel. You may get away without making a selection first if you use the Replace Color feature found in Image > Adjustments, so this is always worth trying first; however, you may find that some contamination of colour makes this difficult. Here the yellow flowers also had red in them, and the idea was to leave them unchanged.

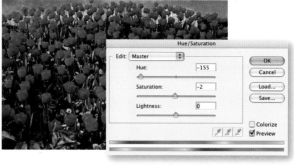

Using the Hue command in Hue/Saturation you can alter the selected areas to create different colours, as shown here.

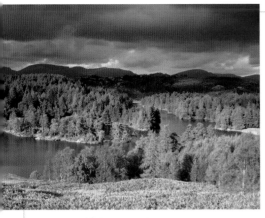

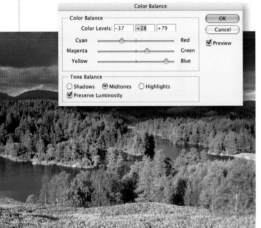

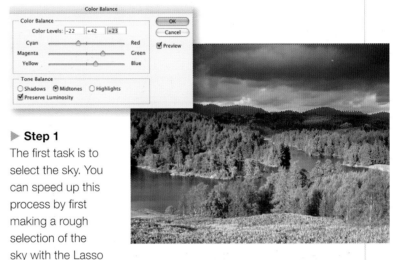

Perhaps a more elegant use for this technique is to correct the very common problem of individual colour casts within an image. In this step-by-step example, the intention is to alter the sky, water and trees separately for precise colour control. This means creating three different selections, but putting some extra effort into a shot always pays dividends in the long run.

▶ Step 1

The first task is to select the sky. You can speed up this process by first making a rough selection of the sky with the Lasso tool and then adding any extra areas using the Magic Wand tool. To correct the purple colour cast use the Image > Adjustments > Color Balance command. Add green first and then cyan and blue to make the sky bluer and more natural, then do just the same to the thin mountain strip in the background.

▲ Step 2

The trickiest part of this project is to select the water. Use the Magic Wand tool with a fairly high Tolerance of 45 to create a first selection. Next, lower the Tolerance to 20 and keep adding little areas using the Shift key until all areas are selected. Then adjust the colour balance (Image > Adjustments > Color Balance) until you have the colour that you want.

Step 3

Next invert the saved selections to create the final selection of the trees. By saving the selections, you can save a lot of time and effort. Open the sky selection first – Select > Load Selection > sky – and then add the mountain by choosing from the Channel menu; you must select Add to Selection to add the mountain channel to the sky channel. The same can then be done for the water selection. By inverting this combination, you will be left with a perfect tree selection in moments.

◀ Step 4

Alter the trees using the Color Balance command: in this example, more red (+15), more yellow (-26) and a touch of magenta (-11) were added to boost the autumn colours. Finish by darkening the entire image using Curves.

As you can see, saving alpha channels for later use is an effective and powerful ally and a great time saver. This technique can be used on any number of subjects to get a pleasing overall effect.

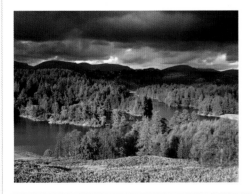

Frames and borders

Putting some finishing touches to a photograph is often overlooked but is very worthwhile, especially if you have spent time and effort producing a pleasing image. Most image-editing packages offer some basic borders and frames, but here we are going to take the process one step further. You can use a camera or scanner to create frames and borders, or make one directly using Photoshop.

Built-in frames

Most image-editing packages come with a variety of frames built in. These are usually adequate for basic needs, but are not very adventurous. Making your own is creative and much more fun.

Creating your own frames

It is relatively easy to get creative with frames. You could choose to photograph a real frame and then drop your image into it. Once you have the real frame in a digital format, simply open a suitable image, drag it across to the frame document, using the Move tool, and place the layer under the frame. Resize using the Edit > Transform > Scale command. You could also try scanning a sheet of torn paper and use this as a template for a frame.

◀ **'Real' frame**
Here an actual wooden frame was photographed using a digital camera and a photo was placed inside it in Photoshop. Try to get the frame as square as possible when shooting, but you can use the Crop tool to finish the job. Select the inside of the frame using the Rectangular Marquee tool, and go to Edit > Clear to delete it. Zoom in and use Select > Transform Selection to fine-tune the selection if needed.

Border masks

More complicated and rewarding efforts can be achieved by creating your own border masks. Proprietary software from Auto FX and Extensis can be purchased to do the same job, but this doesn't have a unique feel to it. The software plug-ins are also expensive for only occasional use. Border masks allow you to create much more complex effects.

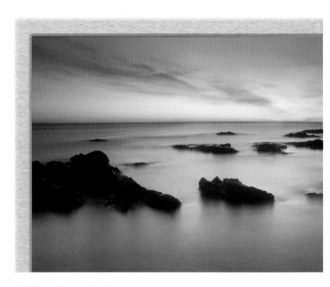

▲ **Ready-made frame**
This is a typical example of the pre-loaded frames that can be used to frame your pictures – a brushed aluminium effect on a plain frame sets off this moody landscape shot perfectly.

◀ **Airbrushed border**
One of the simplest ways of adding a border is to airbrush paint around the edges. Choose a textured brush such as Drybrush or Pastel Charcoal, a size of about 100 pixels and a colour of your choice. Create a new layer if you want to change the colour later on.

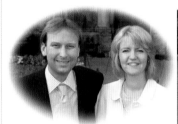

◀ *'Rubbed out' border*
To achieve this effect, create a new document the same size as your image and make the background layer white. Then

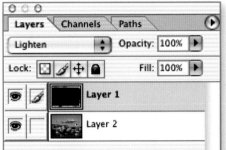

create another layer and slowly build up a mask using a soft brush. Use the eraser at 50% to create grey semi-transparent areas, then flatten the layers to create a mask template. When you paste this into the original photo document with the layer blending mode set to Lighten, the image will appear where the black mask was.

Vignettes

This classic portrait look can be created in minutes. It places emphasis on the subject yet retains a flavour of the background. You can alter the size and opacity of the background, or remove it if this suits the picture better.

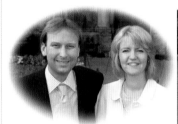
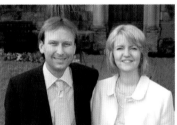

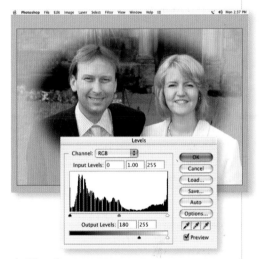

▲ Step 1

First, create a selection using the Elliptical Marquee tool. Drag the mouse across the image from one corner until it is approximately the right size; you can use the Transform Selection tool to alter the shape if needed. Place the cursor within the selection and drag it to fit around the people – remember to feather the selection to create a very soft edge. Then invert the selection using Select > Inverse, and finally save the selection (Select > Save Selection) to save it as an alpha channel.

▲ Step 2

Open the Levels dialogue box (Image > Adjustments > Levels) and use the Output Levels slider to make the background go to white; this is the gradated slider at the bottom of the Levels dialogue box and is the same as the Lightness slider in the Hue/Saturation command. Move the black slider to the right to lighten the selected background.

◀ Step 3

Create a copy file (File > Save As) and re-name it 'vignette template'. Save as a PDF file, not a JPEG. Create a new blank layer and throw away the layer with the photograph on it. As long as you saved the selection, you now have a master template for creating more vignettes.

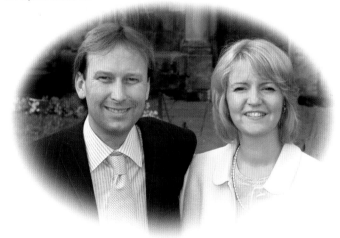

Creating a mirror image

One of the beauties of image-editing software is that you can create images that might occur only once in a blue moon in nature. This technique works particularly well when there is water in the scene. In this step-by-step example, the idea was to create the heart shape of two swans embracing. In real life you may never be lucky enough to see this.

◀ **Step 1**

When you want to create a perfect reflection, the first job is to make sure the original image is perfect. Using the Lasso tool, roughly select any areas of the image that could benefit from a tweak in Levels. Remember to feather the selection. Using the Levels command, move the highlight slider on the right to a better level, here of 176, tweak the middle (midtone) slider, here to 1.18, and finally the shadows slider, here moved to 12. The shadow and highlight sliders control contrast, while the midtone slider controls overall brightness (see page 53).

▶ Step 2

Now you need to create a copy of the original image from which to make the reflection. Here the idea was to have the swans beak-to-beak; use the Rectangular Marquee tool to select carefully around the swan. Then feather the selection by 3 pixels (Select > Feather) and copy and paste (Cmmd/Cntrl C then Cmmd/Cntrl V) to create a second layer.

▲ Step 3

To create the mirror image, go to Edit > Transform > Flip Horizontal to reverse the image on this layer. Then use the Move tool to position the image exactly where you want it. By holding down the Shift key while dragging you can move in a straight line much more quickly than by using the arrows. When you are happy with the join, merge the two layers together (Layer > Merge Visible).

Step 4

In this example, the background needed to be darker, so the Gradient tool was used to add some black colour. To do this, go to the Color Picker and choose black. Then roughly select the top of the background using the Marquee tool. Feather the image by around 50 pixels so that the gradient softly merges with the background. On the Gradient tool, choose the Foreground to Transparent gradient; this and other variations can be found by clicking on the Gradient Editor pop-up menu in the top left corner of the options bar. If you want to darken an existing colour, as here, choose an opacity of 100%.

 If you want to add some blue to a sky, try using a 50% opacity for greater subtlety – you then simply drag the mouse from the top of the selection to the bottom and let go.

▶ Step 5

As a final step, you can use the Clone tool and the Healing Brush to remove any distracting elements, such as reflections in the bottom left corner here. If all the elements are mirrored exactly it quickly gives the game away that the image is doctored; removing some of them makes people look twice and wonder. You can also use the Clone tool and Healing Brush to smooth out the join.

Retouching portraits

People are a difficult subject to master in photography. Unless you have full control in a proper studio environment, with lighting, backgrounds, hairdressers and makeup stylists, you are going to struggle to get a perfect shot. Photoshop allows you to address all of these problems and create a makeover-style shot without all the hassle or expense. The power of Photoshop can also come to the rescue to remove any wrinkles, blemishes or bags under the eyes.

Photoshop's amazing Healing Brush tool, which is now also available in the new Elements 3, is quite brilliant at smoothing things out. Similar to the Clone tool, it goes one step further by blending with the existing colour, light, texture and transparency. The Clone tool always looks a little artificial, but the Healing Brush creates a seamless job.

▶ **Step 1**

Open the portrait you want to retouch. The first area to work on is the skin.

Wrinkles can be easily removed using the Healing Brush. If the effect is too strong, you can use the Fade command to alter the opacity of the last brush stroke. Try to paint over a large area in one go to make full use of the Fade command.

▶ **Step 2**

Use the Healing Brush with a brush size of about 30 pixels to remove any freckles and spots. First Alt/Option and click on an area of blemish-free skin near to the blemish, as you would with the Clone tool, then paint over the area and watch the blemish vanish. Slowly go around the face and remove each blemish.

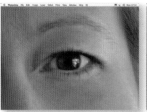 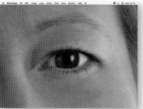

▲ ▶ Step 3

Select the eyes and feather the selection slightly, then use Levels or Curves to brighten them up. Use the Dodge tool with Highlights selected in the Range menu in the options bar to brighten the whites of the eyes.

Here, the highlights in the eyes were distracting, so they were removed using the Healing Brush. However, removing catchlights in eyes altogether makes the image look flat, so create a new layer and add a little white using a small brush. As this is on a separate layer, you can add a small amount of Gaussian Blur to soften it without blurring the rest of the image.

To make the irises black, darken them using the Burn tool. Select the pupils and use the Hue/Saturation command to turn them a different colour – in this case, blue.

Step 4

To boost the colour of the lips, use the Sponge tool in Saturate mode, with a low opacity of around 10% to add subtlety. Always use low opacities to apply colours, to avoid making them look garish.

◀ Step 5

The final job is to add a new background to set your retouched portrait against. Select the background and save this selection using Select > Save Selection. Create a new layer and then experiment with different effects.

In this example, the command Filter > Render > Clouds was used to create a background similar to the kind you might encounter in a professional photography studio environment.

Use the saved selection and then go to Edit > Clear to reveal the new background on the layer below.

Adding a moon

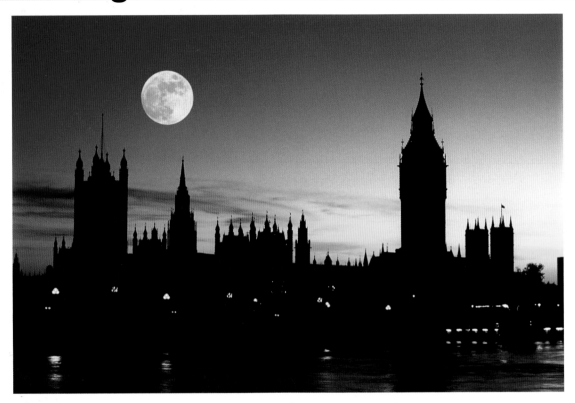

This idea has been very popular with photographers for many years. Before digital manipulation was available, you had to take some shots and rewind the film, making sure registration was perfect, and then re-shoot the moon as a double exposure. The other way was to use a slide duplicator and re-shoot two different slides, one containing the moon. Both methods were difficult, time-consuming and prone to failure. Doing the job digitally is so much easier and quicker, and allows you far greater control over the final effect. This is a good example of adding an element to a scene: you can use exactly the same technique to add other elements in different projects.

◀ Step 1

In order to put the moon on a transparent background it is necessary to make the layer active (double-click the name) by changing it from Background to Layer 0. A transparent background allows you to copy the moon to another document without any background. Then select the black sky using the Magic Wand tool.

You may find that to get a neat outline, without any traces of black sky, it is necessary to go Select > Modify > Expand. Enter a value of 2, which will make the selection grow by 2 pixels. Also feather the moon selection by 1 pixel for a soft outline, and go to Edit > Clear to remove the sky. Remember to keep a master copy in a transparent layer for future use.

▶ **Step 2**

With both documents open, drag the moon across to the main picture using the Move tool. If it appears quite small, use the Transform command to make it bigger. With the moon layer still active, go to Edit > Transform > Scale. Hold down the Shift key while dragging a corner handle to constrain proportions. The moon should not be made too big, or it will look unnatural; use your eye to judge the best size. On occasions a very large moon may work for effect, depending on the shot.

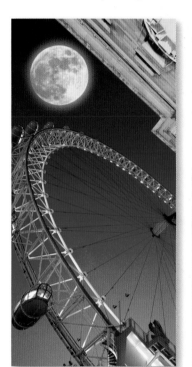

◀ **Step 3**

To recreate the soft glow of the moon in hazy weather, make a copy of the moon layer and apply the Gaussian Blur filter to the bottom moon layer; a value of 60 should give a soft edge. The blur beneath will spread beyond the original and be seen as a glow.

Shooting the moon

There are two main factors to consider when photographing the moon: how to get the right exposure, and how to get it bigger in the frame. The longer your telephoto lens, the larger the moon will be in your frame, and the larger you can get the moon in the frame, the more detail on its surface can be seen. As a rule of thumb the moon is 1mm in diameter for every 100mm, so a 400mm telephoto lens will create a moon 4mm (¹⁄₆in) across.

The downside is that the longer your lens, the more it is prone to camera shake. A sturdy tripod is essential for successful shots. If your camera has a self-timer, use this to minimize camera

shake when pressing the shutter button. This may also lock the mirror up before exposing, which helps reduce vibration.

The moon is quite bright; take a spot meter reading from it if you can. This is better than a full frame reading because it won't be influenced by the black sky. It is difficult to expose correctly, because the black sky will fool the meter into overexposing, so try bracketing your exposures. Use the exposure correction button and set to -1 and -2 and bracket. Digital cameras have difficulty with highlights, often blowing them out – underexposing and shooting in RAW or TIFF mode will resolve these problems.

Try shooting the moon away from streetlights, as these can cause unwanted flare in the shot.

Creating motion and radial blur

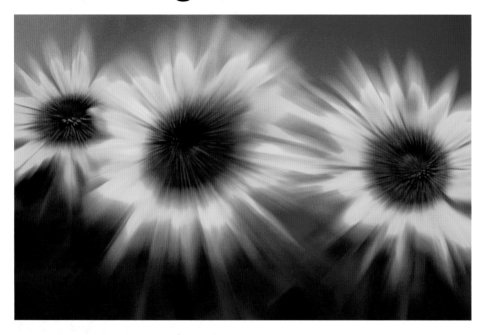

Most image-editing packages come with a selection of clever filters that can recreate the effect of speed and motion in your photographs. Although you can create great effects by panning or zooming a camera when first exposing the image, it is also possible to recreate these results entirely digitally. These powerful effects can usually be found in the Filter > Blur menu.

The effects of motion blur

The image before any manipulation is shown below. The rest of the sequence (above) shows the effects of motion blur with the left, centre and right of the image as the source point.

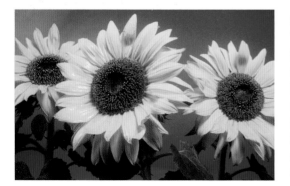

Step 1

To create the final image (top), separate blurs were created from each flower. For this, two extra layers were created and the centre of each flower was then blurred. The Blur filters can be accessed via the Filter menu.

Step 2

The dialogue box (opposite, top) contains several areas and looks quite confusing at first glance. Amount determines how much blur will be applied. In this example, 100% was chosen for the strongest possible effect. Blur Method allows you to choose Spin or Zoom. Spin creates blur in concentric rings around the blur centre. Here Zoom was chosen, which mimics the radial effect of zooming a lens during exposure. Quality determines the final effect. In general, choose Good

quality, as Best will take much longer to generate the effect and the difference between the grades is actually quite small.

The hardest part is determining the origin of the blur. You must place the central cross hair over the point where blur starts, which may take several attempts to get right. As this is a memory-hungry filter, it can take a long time to work. Try making a copy of your image and reducing the file size and then testing out the blur on this smaller image first. When you have the correct effect, re-use the filter on the hi-res image without changing any settings. Command + F is the keyboard shortcut to filter again. In this example, 'blur centre' was placed as the middle layer, 'blur left' the bottom layer and 'blur right' as the top layer.

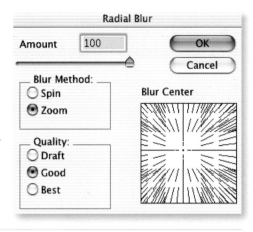

Step 3

Now use the eraser to remove all detail except the right flower on the top layer. Erase the left flower on the centre layer to reveal the flower on the bottom layer.

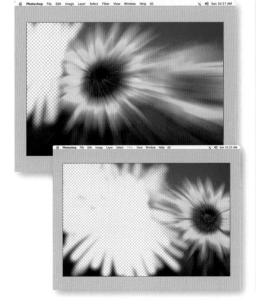

Motion blur

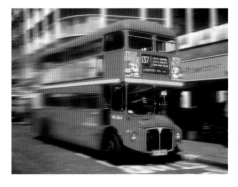

Sometimes the Motion Blur filter can be used in a single pass. Here a more interesting technique is used that combines layers for the final effect. First create a duplicate of the Background layer.

Then choose the Motion Blur filter from the Filter menu. There are two controls – Distance alters the strength of the effect, and Angle allows you to alter the angle. Apply the filter to the entire image.

Use the Eraser tool to reveal part of the original Background layer. The combination of blurred and sharp areas adds to the shot's impact.

Here the back of the bus was selected using the Lasso tool, feathered by 100 pixels for a soft edge and blurred further. This helps to give a more three-dimensional feel to the shot.

The final touch was to make the wheel look as though it was revolving. This is done using the Radial Blur filter. Select the wheel with the Lasso tool and feather the selection by 45 pixels. In the Radial Blur dialogue box, choose Spin and an Amount of 27; too much spin looks unnatural.

Making your own greetings cards

TO MY VALENTINE

Computers allow you to join in the desktop publishing phenomenon known as DTP, which means that you can now create your own sophisticated projects, such as greetings cards, in minutes rather than hours. Image-editing programs have revolutionized the way in which designs are created: long gone are the days of spray-mounted paste-ups and even shopping for birthday cards – you can now produce your own designs, making instant changes to colours and typefaces that, without home computers, would be impossible.

Step 1
Here's how to make an interesting and eye-catching Valentine's card, but the principle applies to any type of greetings card. First choose an image sympathetic to the theme you want to create – in this case roses sum up the feminine and romantic feel that a Valentine's card should have.

If you are uncertain about what your images or text should look like, take a trip down to your local card shop and look at the various different designs used in commercial cards, which should give you plenty of inspiration.

▶ Step 2

Once you have your perfect image, start to manipulate it using different filter effects. To give the image a 'painterly' feel, use the Palette Knife filter from the Artistic submenu: here the Stroke Size is 25, Stroke Detail 3 and Softness 0. Play around with the settings until you are happy, and use the large preview window to view the effect before you apply it.

Step 3

To take the design one step further, create a zigzag selection around the edge of the image using the Polygonal Lasso tool, then feather this by 20 pixels to create a soft edge. You can add any edge effect you want at this stage – try using a photo frame edge, or use Layer Style to add a glow or other effects. Inverse the selection (Select > Inverse) so that the edge of the image is selected, rather than the middle. Then invert the colours using Image > Adjustments > Invert, which gives a nice contrast to the warmth of the red roses and lends the image a three-dimensional effect as though you are looking through a broken pane of glass. You can alter the blue colour slightly to give a more purple effect using the Hue/Saturation command.

Step 4

Now add text using the Type tool, which is a vector tool and thus has the advantage that you can resize the type to any size without loss of quality. The options bar holds lots of information for making changes to the typeface font, size and so on.

Here, Bernhard Modern Standard and Bold were chosen from the font style menu; a font size of 43 points was used to add impact to the short, simple message; use a smaller size if you want to include more text. Left align was chosen to align the text on the left side of the image.

Step 5

To add special effects to the type layer, go to Layer > Layer Style > Blending Options. This opens a dialogue box that looks quite complicated but in reality it is actually fairly simple; in this example Outer Glow was chosen from the options in the left panel. It is then a matter of playing around with the sliders to get the effect you want. Choose Dissolve from the Blend Mode menu if you want to give the type a splattered, grainy look, as here. Spread and Size are the two main controls for altering the overall effect. The range of effects that are possible is quite amazing and each one gives the type a new kind of impact.

Putting a person in another location

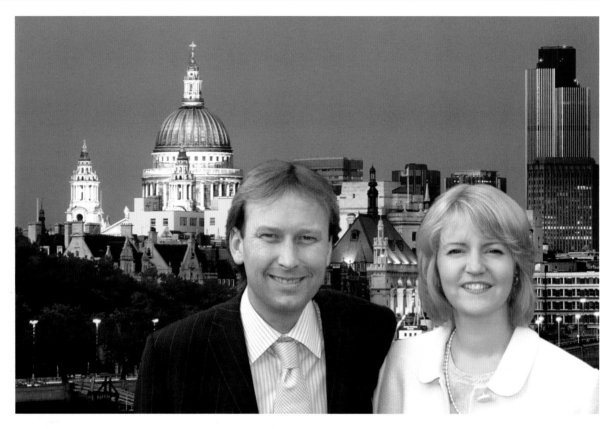

Sometimes you may have a great shot but hate the background because it's ugly, boring or distracts from the main subject. Image-editing software allows you to create some photographic trickery and transport your subjects to any location in the world. Have some fun and try several different contrasting backgrounds. If you don't have any suitably exotic locations, look for royalty-free images on CDs or the Internet.

◀ Step 1

The original photograph had a messy background that is typical of a quickly grabbed shot. It's not always easy to find a suitable background at a moment's notice, which is why digital offers a great solution to the problem.

Carefully select the people in the foreground using the Lasso tool. Use the Shift key to add small areas to the selection and the Alt/Option key to subtract areas. Feather the edge of the selection by at least 2 pixels, and save the selection as an alpha channel (Select > Save Selection).

Step 3

One neat trick, once you have made your selection, is to soften the edges using the Expand or Contract commands: with the people selected, go to Select > Modify > Contract and choose 1 pixel. This will shrink the selection by precisely one pixel, which then allows you to soften the edge gently using Gaussian Blur; the soft edge makes the transition between subject and background more seamless and convincing.

◀ **Step 4**

It is now a question of choosing the new background that you want to set the people against – why not add a scene that you shot on holiday to create your own instant personal postcard? Open a photo that you want to use as a background and then, with the Move tool selected, use the mouse to drag the image across to the people; it may needed resizing, so use the Edit > Transform > Scale option. Drag the top left handle in to meet the edge of the document while holding down the Shift key to constrain the proportions. Then do the same with the bottom right handle; this quickly resizes the imported image. Alter the size of the people using the same method to suit each new background that you try.

A world of possibilities ▶

Using this technique, the possibilities are endless. You can try pasting your people in front of any other image – urban or rural or even ethereal.

◀ **Step 2**

With the people selected, copy and paste them on to a new layer with no background. Go to Edit > Copy, then Edit > Paste (or Cmmd/Cntrl C and then Cmmd/Cntrl V) to paste the people on to a new layer. Once you paste the selection it disappears, so you must save it if you want to do further work on it. The chequerboard pattern shows that the background is transparent, which is exactly what you need to drop a new background in. Use the Eraser tool with a small brush size to delicately tidy up stray hairs and bits of clothing.

Creating a panoramic 'stitcher'

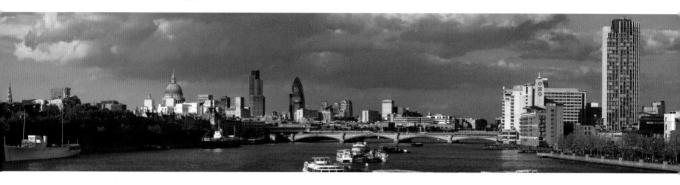

One exciting new development with digital images is that you can create a wide panorama, without the need for a panoramic camera, by 'stitching' several shots together. Adobe's Photomerge is available in both Elements and Photoshop, but there are other third-party solutions available as well; with Apple's Quick Time software you can even create exciting 360-degree panoramas that revolve as a movie.

How to shoot panoramas with a standard camera

Using digital trickery, it is possible to create panoramas from standard 35mm images or the equivalent. When shooting, you should use a tripod to give you a steady platform and allow you to compose each shot carefully. The tripod will also enable you to rotate the camera carefully, for better registration of each image, and keep the horizon level. If you don't have a tripod, keep your feet fixed in one spot and turn the top half of your body. If you get serious about panoramas, there are special tripod heads that keep the optics properly centred for perfect results.

Each shot should overlap by 20–40 per cent for the best effect. If you look at what is at the edge of each frame and include it in your next shot, you should get a good panorama. If you are using a zoom lens don't alter the focal length between shots, and try not to shoot with extreme wide-angle lenses, as the distortion can cause registration problems when merging the shots later on. Make sure the exposure is the same for each shot – any major differences will be glaringly obvious in the final image.

◀ Step 1

Open all the individual images in Photoshop/Elements. Go to File > Automate > Photomerge. If the start images are all open on the desktop, they are automatically chosen to create the panorama. A dialogue box opens to confirm your choice, which you can change if necessary by using the browser. Tick the box to arrange source images automatically.

▶ Step 2

The images appear in the dialogue box, corrected to create a panorama. Any discrepancies in the horizon are clearly visible by the stepped edges. At this stage you have several choices to create the finished panorama.

Lightbox

You can drag images to the lightbox to remove or rearrange them. You can also source new images from different files to add to the Photomerge composition. Any you choose will appear in the lightbox.

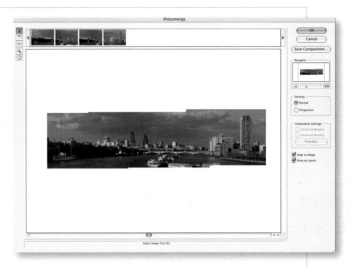

Normal or Perspective

Choose Perspective if you want to correct perspective or change the vanishing point of a picture. The default is the middle image, which has a blue box around it, but you can click on another image to make it the default. This generally doesn't work with distant panoramas.

Cylindrical Mapping

If you select Perspective to correct a problem, you may get barrel distortion, which can be corrected by applying Cylindrical Mapping.

Advanced Blending

This tries to overcome any serious inconsistencies in exposure or colour by creating broader blending between each image. It can save you the bother of doing this job yourself, but can often create other problems that need solving. Parts of buildings may disappear or be copied twice, and skies can develop strange blends that need correcting. Try to mend any problems manually if possible.

Snap to Image

Tick the Snap to Image box to make images automatically overlap and snap into place when an area common to both is found in them.

Keep as Layers

This option is very useful, as it allows you to keep each photograph in a separate layer. Slight differences in colour and tone are a common problem and can ruin the overall effect – being able to correct each layer will allow any differences to be corrected. Once you are happy with the final result, you can then merge the layers into one document.

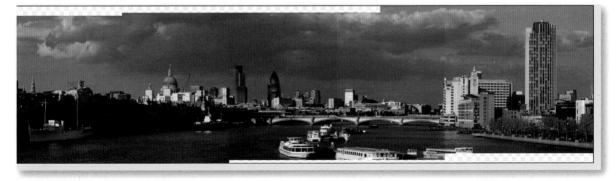

▲ Step 3

The image will almost certainly need some tweaking to finish it off. In this example Levels was used to darken one of the layers slightly, and the Photomerge was then flattened using Layers > Flatten Image. The Clone tool was used to remove some obvious joins in the sky and water. Saturation was increased slightly, and the Unsharp Mask filter was used to apply a little sharpening. Finally, the image was cropped to remove any unwanted edges.

Creating a montage

Montages allow you to combine several photographs together to create images with great artistic freedom. Traditional photographic montages required you to physically cut and paste different images together, and the results often looked fake in all but the most adept hands.

The computer has allowed montages to evolve to a much higher and more sophisticated level, far beyond the limits of traditional methods. They make great use of layers, selections and masks, and will test your skills to the limit.

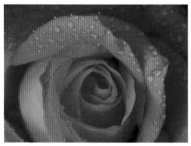

▲ Step 1

To begin the montage, the two pictures you want to use need to be layered in the same document. Simply open both images and drag one image on top of the other using the Move tool.

◀ Step 2

With the images on separate layers, create a duplicate layer of the rose image. Go back to the original rose layer and choose Overlay from the blending mode menu at the top of the Layers palette. This blends the two images together like a double exposure to form your basic background.

▶ Step 3

Now go back to the second rose layer and use the Lasso tool to create a selection, roughly following the edge of the rose. Use the Shift key to add extra bits to the selection, and the Alt/Option key to remove any stray bits. Feather the selection by 200 pixels so the edges fade into the background. Invert the selection (Cmmd/Cntrl I) to select the outer part of the rose, then go to Edit > Clear to remove it. The background now shows through around the edges.

▲ Step 4

The rose looked a little flat, so Levels was used to add extra brightness and contrast: the black and white sliders increase contrast, and the grey slider increases overall brightness. The feathered rose layer was then duplicated to create some small roses: use Edit > Transform > Scale to make the roses smaller. Hold down the Shift key to constrain the proportions, and drag the top right handle. Once you are happy with the size, create several copy layers so you can place the roses around the image. When you move them, there may be faint areas around the edges that need to be cleaned up – use the Eraser tool set to a large soft brush at 50% opacity to clean up the edges gently. On some of the roses here, the eraser was used more severely so that they blended into the main rose.

Step 5 ▶

The image is complete and can be left as it is, but to create the Polaroid effect copy the document (either use Save As and rename the document, or close it and go to File > Duplicate to create an exact copy) and use the method below.

Creating a Polaroid effect

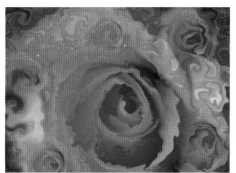

Here's how to create a photograph that looks as if it has been manipulated using the Polaroid film technique: if you attack a Polaroid using a blunt instrument immediately after it has been ejected from the camera, while it is still developing, you can push the emulsion about, creating beautiful abstract images. This sequence shows you how to achieve a similar effect using the Liquify command in Photoshop.

▶ Step 1

Open the document, flatten the layers and then go Filter > Liquify; if you don't flatten the layers, you will end up working on a single layer only. A large dialogue box appears with the image in the middle,

tools on the left and option boxes on the right. Select the Warp tool and begin to smudge the image gently. It is best to build up the effect slowly using a small brush – here, a brush size with a radius of 64 was used. If you own a Wacom Art Pad or similar this process is easier – just like painting.

◀ Step 2

Choose the Twirl Clockwise tool to swirl the image. Click and hold down the mouse or pen, and the effect happens automatically until you let go of the mouse. You can also drag while holding down the mouse or pen.

The Liquify filter allows you to achieve an amazing variety of effects – you can even mask or freeze part of the image or keep an image in layers and apply different effects to different layers.

Hand tinting

Hand tinting has been a favourite technique since photography was invented. It was used for many years before colour film was available, and has since been used to great creative effect by many photographers, especially when trying to create a feeling of age or to add a delicate mood to black-and-white prints. Traditional hand tinting on photographic paper requires much experience and expensive oil colours to achieve the required effect; the digital method allows you to use layers, so that you can easily go back and correct mistakes.

▶ **Step 1**

Start with a grayscale image that has been converted to RGB mode so that colour can be added. The first job is to create a copy layer. Next, open the Hue/Saturation command and tick the Colorize box to create an instant one-coloured effect. By sliding the Hue to 36 and the Saturation to 33 you can create a lovely sepia tone effect. Leave the Lightness slider alone.

◀ ▼ **Step 2**

To create a black-and-white effect for the people while retaining the sepia background, you need to select the clothing. Select the entire bodies except

the faces and other skin areas using the Lasso tool.

In the traditional hand-colouring technique, the skin tones are sepia-toned to create a warm skin colour, on to which subtle colour can be applied. Fine-tune the selection process by using the Shift key to add to the selection, and the Alt/Option key to remove from the selection; remember to feather the selection by around 3 pixels for a soft edge. Then go to Edit > Clear to reveal the black-and-white version beneath.

Step 3 ▶

Next you need to create a new empty layer so that you can start to colour individual parts of the image, thus allowing you greater control over the final outcome. In this example a purple colour was chosen from the colour swatches, and the tie was selected and feathered by 3 pixels. From the blending mode drop-down menu at the top of the Layers palette, choose Overlay, which allows you to paint transparent colour over the image – leaving it in Normal mode would create an opaque effect, which would destroy all the detail underneath. Try it for yourself and see what happens; in this case, the Edit > Fill command was used with 25% opacity.

◀ **Step 4**

For each area you want to colour, create a new layer so that you can maintain fine control of everything. Here a new layer was used to add colour to the flowers. Use the colour swatches to hand-pick colours, and slowly build up the colour using the Brush tool with an appropriate brush size and opacity. This is exactly the same as traditional hand-colouring techniques, but with much greater control. If you make a mistake, just use the History palette to undo the problem.

Step 5

Create new layers to add colour to faces and other skin areas. Use a small brush size and low opacity, as in Step 4, to add a little colour to cheeks, feet, hair and arms. Here the bride's eyes and lips have also been coloured. Back on the sepia-toned layer, use a small brush and the Sponge tool in Desaturate mode to remove the colour from the teeth to give them a more natural colour.

▼ **Step 6**

Staying on the same layer, remove the sepia colour from dark hair. Select it, feather it by 3 pixels, and go to Edit > Clear to give it a more natural colour. Hand-tinted prints make lovely presents for friends and relatives, especially if they are the subjects. Try the technique with modern photographs, too – it's amazing how well it can work, giving them a feeling of nostalgia that could never be found in the original colour images.

Repairing a damaged photograph

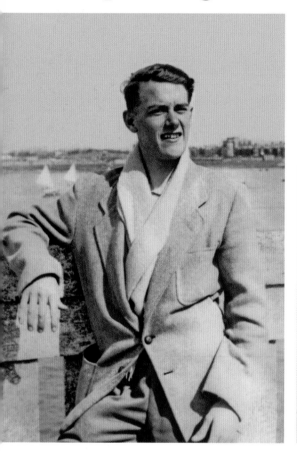

We've all got a box of old, cherished photos gathering dust somewhere, and with digital technology it's a simple task to repair those that have been damaged by the ravages of time – dust, scratches, tears, stains and even missing areas can be successfully repaired. This is also an opportunity to archive all your old photos and save them on to CD or DVD.

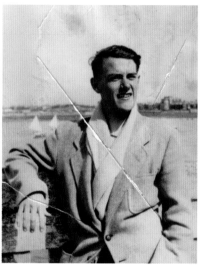

▶ **Step 1**

First you need to digitize the old image by scanning it (see page 46). Even if the image is black and white, scan it in RGB mode to capture as much information as possible. It is also possible to copy photos using your camera: use a tripod to get the image pin-sharp and to make cropping easier. It is best to shoot using bright, diffused natural light to avoid reflections; a macro zoom facility helps to get images to fill the screen.

▶ **Step 2**

The first thing you should do in Photoshop is to convert the image to grayscale, as this is the quickest way to remove coloured stains and any colour cast picked up by the scanner. If you want to add a colour sepia tone effect later on, you must convert back to RGB again.

Copying an image always adds contrast; Image > Adjustments > Shadow/Highlight allows you to tweak the shadows and highlights of the scan so you can adjust this problem.

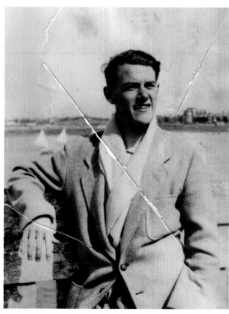

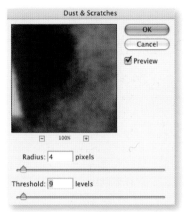

▲ ▶ Step 3

The quickest and simplest way to remove noise and small bits of dust is to apply Filter > Noise > Despeckle then Filter > Noise > Dust & Scratches. Despeckle is a simple filter with no controls (you can use Edit > Fade), but the Dust & Scratches filter needs to be used with care.

In this example, Radius was set to 4 pixels and Threshold to 9 levels to prevent the effect getting out of control. Keep altering the sliders as you go, and look at the preview regularly to ensure that you get the desired effect. Use Dust & Scatches for lots of very small dust, and the Clone tool for larger blemishes.

Step 4

The best tools for the tears are the Clone tool or the Healing Brush. The Healing Brush works better on areas of similar tone and doesn't like boundaries where there are sharp changes in contrast. In this example an area very close to the tear was sampled using the Alt/Option key and then painted in the direction of the tear. Click on Aligned to make the sample point follow the brush or you will keep sampling from the initial point, which won't work. Opacity changes the maximum

amount of paint you can apply, and Flow lets you apply the paint more slowly so you can build the effect up. Lowering the flow when working on smooth areas of similar tone allows you to match colours more easily.

◀ ▶ Step 5

Cloning every blemish in the background would obviously take a long time. A quicker solution is to select the background carefully with the Lasso tool, feather by around 10 pixels and then Edit > Fill with a solid colour at 100% opacity. Use the Eyedropper tool to select an appropriate shade from the picture to get a good colour match. A good trick is to use Edit > Filter > Add Noise at a setting of 2.5% to add a little grain to mimic the original. Before selecting the background, create a new layer in case you want to change the opacity. Check the entire image for anything you have missed.

As a final effect you can add sepia tone using the Hue/ Saturation command. The Colorize button creates a monochromatic colour effect.

Adding text and graphics

One very powerful and valuable tool is the Text tool. This is a vector tool that allows you to resize the type to any size without loss of quality. If you save the file with its type layers intact (and tick the box 'Include Vector Data') in PDF or EPS format, the type retains its vector qualities and can give true professional-quality output if sent to a professional printer. Using type is just like typing with a word-processing software package: if you can type a letter or document, you can use the Type tool.

The Type tool

When you select the Type tool and start typing, a new type layer is automatically created. You can create several layers in the same document and apply different styles to each. You can also place single words or headings as point type by typing next to the cursor, or you can create a bounding box for paragraph type where you want to write several lines or paragraphs of text. When you have finished, click on the Commit button (the tick shape) in the options bar.

Choose a typeface you like from the fonts list, then choose the point size (this is how type is measured) from the font size menu. Finally, use the colour swatches to pick a colour. All these attributes can be changed at any point, as long as the layer remains active and is not merged.

Trade Tips

✏ You can buy extra fonts on CDs or try searching the Internet for free font downloads. Some companies, including Adobe, have a library where you can buy individual fonts as and when you need them.

✏ Use software such as Extensis Suitcase to manage your fonts if you have large numbers of them. Too many fonts in the font folder can slow down your computer. Suitcase allows fonts to be turned on or off quickly and easily.

Selecting text and altering colour

If you want to re-select text, first select the appropriate text layer and then click the mouse next to the text; a flashing cursor will appear.

Drag the mouse across the text to select it, then double-click the 'Set foreground color' box and choose a different colour.

Using layer styles

Layer styles are a very powerful way of altering text as well as other selected elements within an image. Go to Layer > Layer Style, then choose a style such as Drop Shadow. You can also access the layer styles at the bottom of the Layers palette. On doing this, a rather complicated-looking dialogue box appears, but this doesn't take long to master.

Each style has its own box, with different parameters that can be changed. You can also combine several different styles to create the final effect.

Pattern Overlay

Outer Glow

Inner Shadow

Color Overlay

Satin

Drop Shadow

Bevel and Emboss

Gradient Overlay

Stroke

◀ **Text examples**
These text examples show some of the effects possible and the dialogue box settings that were used. Use them as a starting point, and experiment to create new styles.

133

What you can do with type

Type is just as versatile as any other element in Photoshop.
Here are a few key points to get you started.

1

You can type a single heading

Typing a single heading

When you start typing, click on the area of the page where you want the text to start from. A flashing cursor tells you that you can begin typing. If you move the cursor outside the text, it automatically turns into the Move tool so you can reposition the text. You can also select the Move tool from the toolbox and use the keyboard arrows for very fine movements.

Creating a boundary

Select the Type tool in the toolbox and drag the mouse to create a bounding box. This restricts the type to the edges of this box so paragraphs of text can be created quickly and easily. Holding down the Alt/Option key brings up a Paragraph Text Size dialogue box that allows you to enter a specific size.

2

Select type by dragging with the mouse over the text

Selecting type by dragging

To select the type to change colour or size attributes, choose the relevant text layer then click the mouse at the beginning of the text and drag along it to the end.

 ### Altering the height, size and width of the text

Use the Character dialogue box to alter the text height, size and width. Use the Auto spacing feature to change the space between the lines (known as leading).

1 **You can alter the height and width of individual lines of text with the Character dialogue box. It also allows you to alter the leading or spacing between the lines. Select one or more lines to alter using the mouse.**

2 **You can alter the height and width of individual lines of text with the Character dialogue box. It also allows you to alter the leading or spacing between the lines. Select one or more lines to alter using the mouse.**

Warp type
Select your text and then click on the Warp Text command, which can be found in the options bar at the top of the screen. The dialogue box opens and has 15 styles to choose from, which can also be adjusted further using the sliders.

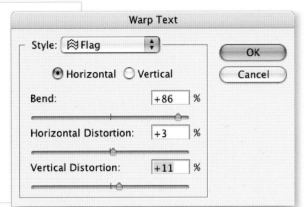

Justifying text
In example 1 below, the paragraph was left-aligned, so the left side is nice and straight but the right side remains ragged. This basic setting can be found on the options bar or in the Paragraph palette. In example 2, the paragraph was right-aligned using the same method; make sure all the text is selected before changing the alignment. In example 3, the paragraph was justified both left and right, creating a symmetrical rectangular shape; using 'Justify last left' means the last line of text stays on the left, but you can place it to the right or centre it. You must use a bounding box to use these settings, which are found on the right-hand side of the Paragraph palette.

1

1 Justifying a paragraph helps to tidy it up and allows you to keep a style throughout the entire design. You can specify whether to justify to the left or to the right or you can centre the type in the middle. Changes can be made using the Paragraph palette which is conveniently placed with the Character palette. Placing the text within a bounding box to create paragraph text allows you to make more changes than if left as point text.

2 Justifying a paragraph helps to tidy it up and allows you to keep a style throughout the entire design. You can specify whether to justify to the left or to the right or you can centre the type in the middle. Changes can be made using the Paragraph palette which is conveniently placed with the Character palette. Placing the text within a bounding box to create paragraph text allows you to make more changes than if left as point text.

3 Justifying a paragraph helps to tidy it up and allows you to keep a style throughout the entire design. You can specify whether to justify to the left or to the right or you can centre the type in the middle. Changes can be made using the Paragraph palette which is conveniently placed with the Character palette. Placing the text within a bounding box to create paragraph text allows you to make more changes than if left as point text.

2

3

Using the Shape tool

Underneath the Text tool is the Shape tool. You can choose a standard shape or select the Custom Shape picker, which can be found in the options bar, to access the extensive library of pre-made shapes. These allow you to create a design quickly for something such as a card or a calendar. Keep an eye out for free shapes and typefaces – they are often bundled on CDs or can be downloaded from the Internet; simply add them to the relevant folder or library in Photoshop's application folder by going to Edit > Define Custom Shape.

◀ *Using shapes*

This colourful card design was created in a few minutes to show how effective using shapes can be. Because shapes are vector paths, you can resize them to any size without any deterioration in quality. Shapes can also have layer styles applied to them, such as drop shadow effects.

Using the type tool

There are many ways to add text to an image; here a simple and quick method is used to illustrate the many uses of the Type tool.

I carefully chose this sunflower image to be the ▶ *front cover of a calendar. When choosing an image for this sort of use, make sure it is simple and the type doesn't get lost in the picture.*

◀ *A bold typeface called Burito was used so that the type would stand out. Choose the font from the 'Set the font family' drop-down menu. To make the type big enough, choose an appropriate point size from the 'Set the font size' menu; in this example 150pt was set. Choose 'Center text' so that as you type the lettering will automatically be placed in the middle.*

Before typing choose a colour for the 'Set foreground color' box found in the toolbox. You can use the swatches or double click the box to open the Color Picker and choose a different colour. The text will automatically be placed on a new editable text layer when you start typing, so you can make any alterations at a later date.

▲ ▼ *Custom shapes*
Using tree, leaf and snowflake custom shapes in black, a snow image was imported, and the Lighten blending mode was used to create an instant card design ideal for Christmas. You can use this seasonal idea throughout the year to produce eye-catching yet simple and quick designs.

To select the type click Select > Color Range, ▶ then click on the white text. A series of 'marching ants' appears around the text. The sunflower layer was made active by clicking on it and the text layer eye icon turned off so that I could view the next effect. Click Image > Adjustments > Invert to make the colours go to their opposite values. You can then use Curves to brighten the text effect so that it doesn't disappear. The result is a simple yet striking cover design for the calendar.

Creating a simple website

Creating your own website may seem like a daunting task at first, but with Photoshop/Elements Web Photo Gallery you can have your own site up and running in no time. Most people who are interested in digital photography have an Internet connection with a local ISP (Internet Service Provider), and many of these companies provide free space on their sites, so you can upload your own images on to them.

Why not go further and create your own professional-looking website to give your work an instant air of accomplishment? Adobe have developed an automated website creator that creates a website in minutes. Before the inclusion of this software in their products, it could take you days or weeks of hard graft to achieve something similar.

Step 1

Collect a group of images together and put them in one folder; label this 'Photo collection'. Next resize each image to about 6x4in and 72dpi. With Photoshop, you can use another of its nifty timesavers called Actions (see opposite) to do this boring, repetitive job for you.

Step 2

You now have a group of small images in a folder to use on your website. Now create a new empty folder using File > New and name it 'Website'. This folder is important and will eventually hold all your website

folders; if you save the folders to the desktop, you run the risk of misplacing a file, and the site will not work. Now create a third folder and place the other two folders inside it so everything is easy to find.

Step 3

In Photoshop go to File > Automate > Web Photo Gallery; a new dialogue box appears. Choose a website style (you may want to try several styles to see which one you like) and type your e-mail address in the Email box. In Source Images select Choose to bring up 'Select image directory' and find your images in the folder called 'Photo collection'. Select Open. The computer now knows where to find the source images.

Creating an action

Step 1
Open a photo.

Step 2
Open Actions by going to the main menu – Window > Actions.

Step 3
Click on the arrow top right of the palette and select New Action from the menu.

Step 4
In the dialogue box create a name such as 'Make 6x4 72dpi' and click Record. At the bottom of the palette the record button goes red to confirm recording.

Step 5
Go to Image > Image Size, change the width, height and resolution and click OK. Now click Save As and name the image.

On the left, next to the Record button is the Stop Recording button; click this when you have finished your commands for a new recording to reduce the size of an image. In the Actions palette click the Modal control square, on the right of the tick next to the Save As command. This brings up the Save As dialogue box so you can name each picture and save it with a new name.

Open an image, open Actions, select the required action and press Play at the bottom of the palette and the action is played.

▼ Step 4

Select Destination and a dialogue box called 'Select a destination location' appears. Select the empty folder named 'Website' and open it. You can now create a website as is or choose a few options. The computer now knows where to store the final website folders.

Publishing your website

Once you have created your website you will want to show it off to the rest of the world. You need to do two things: first, sign up with an ISP if you haven't already done so; second, you need to get some software to 'upload' the folders to the ISP server.

Finding an ISP

There are many ISP companies to choose from. You can search the web or dedicated magazines for comparisons between different companies to get a good idea of prices and services. The broadband market is expanding rapidly, and prices are falling just as fast; you can even pick up CDs at supermarket checkouts that offer free broadband connection for a limited amount of time, at the end of which you are invited to sign up with the supplier.

Broadband with 1 or 2MB speeds is now becoming increasingly popular, and the prices are currently not much more than those of standard 56KB modem speeds. The speed of broadband is far superior to that of a 56KB modem, which is often supplied as the standard modem inside a computer. If you opt to buy broadband you will be supplied with a new modem, usually a separate component, that will allow you to dial up.

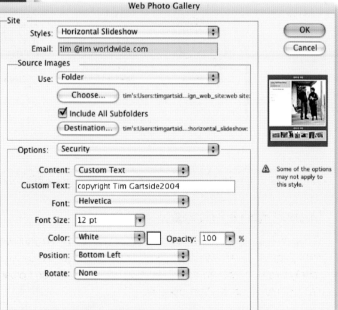

▶ Step 5

In the Options menu choose Custom Colors and select the colour that you want to use for your background. Now choose Security and type in your details choosing the font you want and using a small font size – this information will then appear on the actual image and helps to stop unregulated downloading of your images. Click OK to start the process.

Uploading your website using FTP

Many ISP companies give you free space on their server where you can place your website or even several websites. You will need to use FTP (File Transfer Protocol) software to communicate with the host server at your ISP provider. Once you have this, you simply copy the folders to their server using the FTP software: this is called uploading. They often have free software that allows you to upload but you can also choose your own server and software if you have experience. For most people, the chosen ISP will provide all they need.

If you already have Web design software such as Macromedia Dreamweaver or Adobe GoLive, the FTP software should be included and you simply upload from within the software package. These packages also allow you to develop very slick advanced websites, but as with all software, you must be dedicated to learn how to use it properly and get the most out of it.

Once you have uploaded your website you can change it at any time. You may be able to upload only the new alterations or you may have to upload the entire site again, depending on your software.

Trade Tips

◾ Look online and in magazines to compare prices and services of different ISPs – this market is particularly competitive as new products are introduced, so you can pick up some great bargains.

◾ When creating your pictures for your website, make sure they are not too big and are only 72ppi. This will allow them to download quickly on even a 56KB modem – and, more importantly, you will not be giving people access to hi-res images that they can download without your permission.

◾ If you want people to return to your website again and again, keep it up-to-date so that there is something new for them to look at each time they visit.

◀ **Step 6**
You should now have a folder called 'Website' containing six items. This is the end result of your efforts and should open up automatically using a default Internet browser such as Internet Explorer, Netscape Navigator or Apple's Safari. If it does not, open up your browser and choose File > Open, find the 'Website' folder and select the file named index.htm, which is the root homepage file. This will open and run the website.

Uploading the website to your ISP

You should be able to find instructions on how to upload your website on your ISP's homepage. You will need a simple software package to allow you to upload; this is usually free to download from the ISP provider, or you can upload using Adobe GoLive (right) or Macromedia Dreamweaver.

Printers

Once you've photographed your image and spent time and effort manipulating it, you can create prints for family and friends, for your own photo album and to put in frames for display. There are several different ways in which you can create a print.

◀ *Inkjet printer*
The size and shape are similar to those of a standard desktop printer.

How inkjets work

Inkjets squirt hundreds or thousands of tiny ink droplets through tiny holes to make up the picture, using either a thermal or a piezo-electric method. State-of-the-art printers with six to eight inks create all the delicate shades in a photograph; cheaper models using only four inks display grainy characteristics.

Inks

Standard printing uses cyan, magenta, yellow and black ('key'), otherwise known as CMYK, in the traditional four-colour process. Photo printers now incorporate extra colours, such as light cyan, light magenta, light black and extra red and green, to create a smooth, even tone. Some models also use light grey to produce more neutral black-and-white prints.

Modern ink technology is so good that archival prints can now be achieved. Standard dye-based inks have a life expectancy of 10–25 years, while more expensive pigment-based inks are expected to last for over 50 years. This compares well with traditional RA4/Cibachrome prints, which last between 15 and 90 years. Specialist third-party manufacturers such as Lyson or Perma Jet

Inkjet printers

The most popular choice is an inkjet printer. Quality, speed and price have improved dramatically, in line with digital camera technology. They are more economical than a dye sub printer (see page 150) and much quicker and easier than going to a lab. You can also produce prints at many different sizes and put paper back in again if you used only part of it, unlike dye sub printers. Quality is now getting to the point where an inkjet print is indistinguishable from a lab print. You can also use an inkjet for day-to-day printing of letters and other home/office printing.

Choose a model that allows photo-realistic prints to be made: most people are happy with an A4 printer (21x29.7cm/8¼x11½in), but get an A3 printer (29.7x42cm/11½x16½in) if you want large, exhibition-style prints.

Versatility ▶
More and more printers are capable of working with a variety of paper sizes and shapes.

produce archival-quality pigment-based inks and papers, but unless you are planning to sell your work, ask yourself if you really need to use pigment inks instead of dye inks.

Standard dye-based inks last for many years in good conditions. The amount of fading depends on how you look after the prints. Ultraviolet (UV), found in sunlight, is the worst offender, attacking inks and making them fade quickly. Keep prints out of direct sunlight and use UV fade-resistant glass and proper archival matting when framing. There are also UV sprays available to coat prints. For

◀ *Cartridges*
Look for companies that can refill cartridges and make savings.

maximum archival performance, store prints in acid-free boxes, and keep a copy of the original on CD or DVD.

If you do a lot of printing, buy a printer that uses separate ink cartridges so that you can change each one as they run out. Older systems use one cartridge for all colours; when one colour has run out, the whole cartridge has to be thrown away.

Third-party inks

Third-party suppliers can offer cheaper alternatives to printer manufacturers' expensive inks. Try out several to find one that suits your printer. Using them may invalidate your guarantee, so read your terms and conditions carefully before using them. Ink quality can vary, especially when used for photo-quality prints.

The choice of paper

Choosing the right paper for the job is essential. For high-quality professional results use a heavyweight gloss paper, which gives the best sharpness, colour saturation and feel. Matt papers give a subtler rendition ideal for display, and tests suggest they last longer than gloss prints. There are many other types with different surfaces; some have textured coating for a watercolour-style effect.

Manufacturers' papers work well with their own printers, but independent paper companies also make good products. Check out magazines for comparison tests; start by using the printer manufacturer's paper, then experiment with other papers. Each brand has its own colour characteristics: Canon paper tends to print warmer than Epson, for example. Each paper you use needs to be calibrated and the colour tweaked – one paper may need more cyan and another less. Access the Custom control menu in the printer settings menu, choose the colour settings and tweak the colours and brightness until you have a perfect print.

Print calibration (see page 148)

This method is for an Epson printer, but Canon and others have very similar processes. The system is useful if, once you have calibrated your monitor, you have a recurring colour cast or brightness problem.

Step 1
Choose Custom in your Printer dialogue box. Now choose Advanced.

Step 2
Choose Color Controls from the Color Management.

Step 3
You now need to decide if the print is too dark or light, and what colour to add or subtract. Density, contrast and saturation are straightforward. Working out a colour cast is not always easy, but trial and error should get you there in the end (see page 154). Uncheck high speed and check finest detail.

Step 4
When happy with the colour and density, save the setting. Do as many as you like for different papers, making sure each has a clearly defined name for easy reference.

Printing

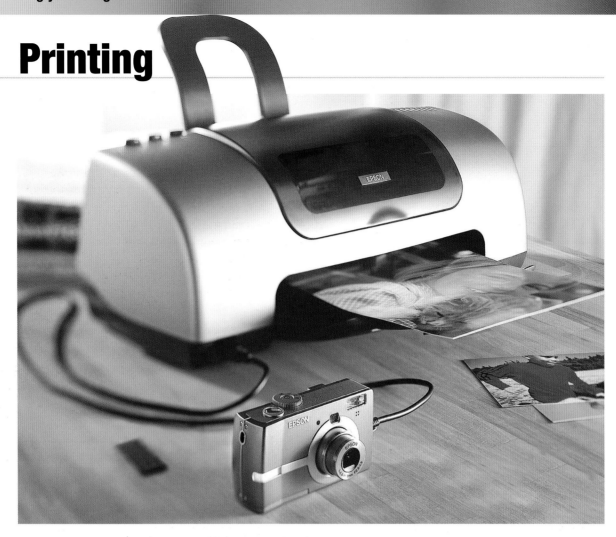

Printing is the final stage in the process of capturing a photograph, where the image is finally outputted. Paper prints allow you to view your photos at any time – you can place them in a frame, on the wall or in a photo album to share with family and friends whenever you choose. Printing on to paper is also an excellent way to archive your precious images in case your digital master copy is somehow lost, damaged or corrupted.

Many people take digital images and then leave them on the computer where they get forgotten about. Seeing your images in print around the house or office will instantly bring back those memories of all the good times you've had. Isn't that why you took the pictures in the first place? So what are you waiting for? Start printing!

Getting the colour right

Many factors can affect the final colour of a print. The monitor, scanner and camera are in RGB colour, while the printer reproduces colour in CMYK mode; these colour spaces have different 'gamuts', or total ranges of colours, and some colours do not print as they appear on screen. These colours are known as 'out of gamut'.

To get the colours to print as accurately as possible, you must create a closed-loop colour system, where you are in control at all stages from input to output. This is created by calibration. In the world of colour there is often an alarming number of different colour spaces to choose from. This might sound complicated, but it is quite straightforward really; it is just a question of rationalizing all the colour spaces you use to make them match wherever possible.

The lab colour space is a representation of all colours visible to the human eye, and encompasses both RGB and CMYK colour spaces.

The RGB colour space is generally wider than the gamuts of most CMYK devices.

◄ **Colour gamuts**

This diagram shows different colour gamuts, or colour spaces. All devices have their own colour gamut: for example, a monitor has a wider gamut than an inkjet printer, which is why colours never look exactly the same on screen and on paper. If the colour of one device falls outside the colour space of another device, it is said to be 'out of gamut'. Most devices have different gamuts so absolute colour consistency is virtually unattainable; the best you can do is get as close as possible. In general blues and cyans are the most problematic colours – they don't 'travel' well between different spaces.

The **camera** shoots in RGB or sRGB. If possible, choose an industry standard colour space such as Adobe RGB 1998; sRGB has a smaller colour gamut and is more suitable for Web pages, which use a smaller range of colours, than for printing.

Some, but not all, scanners can have their own colour space defined; choose Adobe RGB 1998 if possible.

Software such as Photoshop CS can also work in Adobe RGB; you can find this setting in the Color Settings menu. Choose Custom and Adobe RGB 1998 in the Working Spaces menu and Preserve Embedded Profiles in the Policies menu. In Photoshop Elements 3 choose Full Color Management.

The **monitor** can also be set up to be part of a WYSWYG, or 'what you see is what you get', closed-loop system. All monitors show colours slightly differently, and LCD monitors also look different to tube monitors. The WYSWYG system allows you to create an accurate colour profile by eye for your particular system, but may not work for other systems. This is important only when you are sending work to a printer or repro house,

where colour profiles need to be worked out to suit both parties.

Start by using the Apple/Adobe Gamma colour calibration tool for your monitor screen. Follow the step-by-step guide to give your monitor a good starting point. Once you've completed the contrast, brightness and colour steps, you should have a calibrated monitor that gives faithful colours. Remember, the colour on your monitor won't affect the final print colour unless you start changing the colour using Photoshop; in this case, a correctly colour-balanced monitor becomes essential. Usually the printer needs to be tweaked, not the monitor.

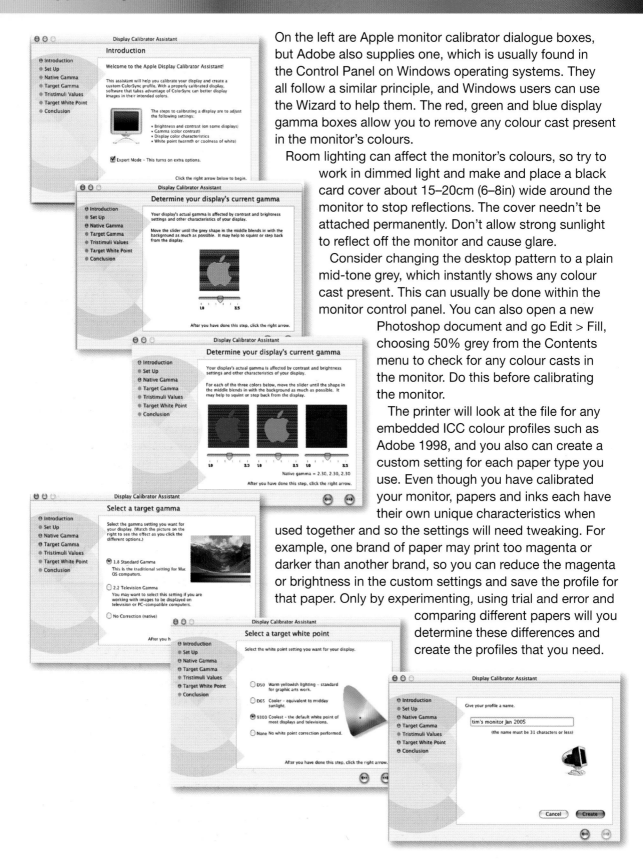

On the left are Apple monitor calibrator dialogue boxes, but Adobe also supplies one, which is usually found in the Control Panel on Windows operating systems. They all follow a similar principle, and Windows users can use the Wizard to help them. The red, green and blue display gamma boxes allow you to remove any colour cast present in the monitor's colours.

Room lighting can affect the monitor's colours, so try to work in dimmed light and make and place a black card cover about 15–20cm (6–8in) wide around the monitor to stop reflections. The cover needn't be attached permanently. Don't allow strong sunlight to reflect off the monitor and cause glare.

Consider changing the desktop pattern to a plain mid-tone grey, which instantly shows any colour cast present. This can usually be done within the monitor control panel. You can also open a new Photoshop document and go Edit > Fill, choosing 50% grey from the Contents menu to check for any colour casts in the monitor. Do this before calibrating the monitor.

The printer will look at the file for any embedded ICC colour profiles such as Adobe 1998, and you also can create a custom setting for each paper type you use. Even though you have calibrated your monitor, papers and inks each have their own unique characteristics when used together and so the settings will need tweaking. For example, one brand of paper may print too magenta or darker than another brand, so you can reduce the magenta or brightness in the custom settings and save the profile for that paper. Only by experimenting, using trial and error and comparing different papers will you determine these differences and create the profiles that you need.

Step 1

Picture quality depends on the resolution of the image. Try to use 250–300ppi as your standard document resolution. You also need to make the photo the correct size for the paper output.

▶ Step 2

Choose File > Page Setup from the main top menu bar. Choose landscape or portrait orientation and your chosen print size, such as A4 or A5. On newer printers you can also choose scale or borderless printing.

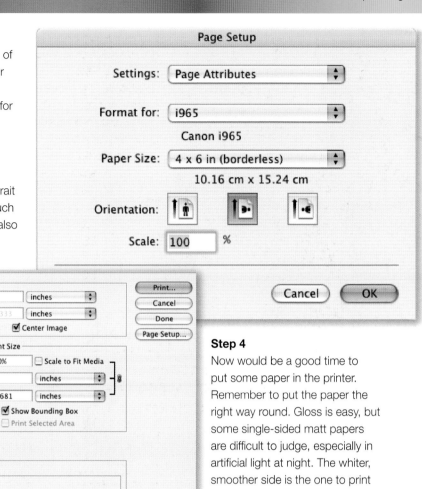

Step 4

Now would be a good time to put some paper in the printer. Remember to put the paper the right way round. Gloss is easy, but some single-sided matt papers are difficult to judge, especially in artificial light at night. The whiter, smoother side is the one to print on (except for textured paper). Mark the envelope or packaging so you know which is the front for future printing. When you are happy with the size and layout, choose File > Print.

▲ Step 3

Choose File > Print Preview. This is useful to see automatically whether you've chosen the wrong print orientation, and it is always worth checking, as it can save wasting paper and ink in the long run. The setting also has precise methods of changing the position, but these usually need to be used only for double-sided printing. You can, however, alter the scale and move the image around the printable area – this is useful if you want a white border around the image for framing later. Dramatic rescaling can cause distortion to the image.

 At the bottom tick the Show More Options box for extra colour print settings. Choose Color Management and select Document in the Source Space. Choose either Printer Color Management or Same as Source in Profile and Perceptual in Intent.

Step 5

In the printer dialogue box you can choose the basic auto print, photo enhance or custom modes. In Quality/Media Type choose a paper type – if you don't have an exact match, use the closest one. In Auto mode use Speed for quick unimportant work and Quality for best work. Click on Custom and then Advanced to create your own profiles. Use the colour controls in the Color Management section and play around with the settings until you get a perfect print – this may take a while! You can then save the setting for future use. Then hit Print.

Choosing custom modes ▶

The print dialogue box allows you to choose from auto or custom modes for print settings.

Advanced settings ▶

In these settings you can choose to remove a colour cast and alter brightness, contrast and saturation. Too much saturation causes colours to go out of gamut very quickly, so use it sparingly. De-select High Speed for finer printing. Here the colours have been tweaked for a particular paper; you can choose Save Settings to save the paper profile for future use.

▼ **Apple OS X printer settings**

These two screengrabs show the print settings in Apple's OS X software.

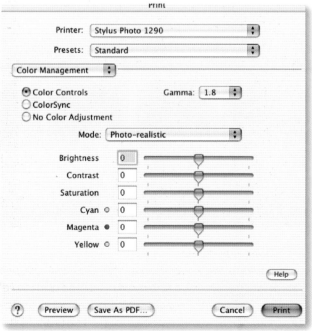

Creating a test strip

This technique is similar to the one used in a traditional darkroom; like many other darkroom techniques, it is equally valid in the digital world. The idea is to use a small test strip on a sheet of paper to assess colour and density.

Use the rectangular Marquee tool to select a small area within the image that has important highlight/shadow detail or an area where colour is critical. Use Edit > Copy and then Edit > Paste to place the selected area on a new layer. This allows you to print several sections of the image at once, such as the sky and land. Turn off the Background layer eye icon, or it will also print.

Choose File > Print with Preview to open the dialogue box, un-tick the Center Image box and move the small test strip to the edge of the paper's bounding box. Remember to move the strip along for each new test or the strips will print over each other. Use a sheet of the paper you will use for the finished print for accurate results. This is a very economical way of saving paper and ink if you are struggling with a difficult print.

▲ **Test strip layers**
Here you can see that the background eye icon is turned off so it doesn't print.

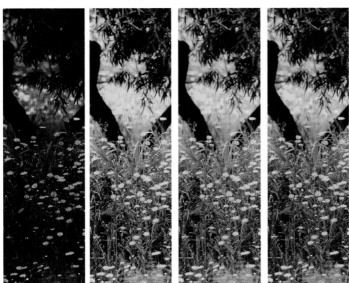

▲ **Creating a test strip**
Here the first attempt produced a rather dark and cyan print. The second attempt went too far the other way and was too light and red. The third attempt was almost there, but was a little too yellow. The final test added a little blue to get the colour spot-on.

Trade Tip

🖐 Try to print during the day so you can use window light to check that colours are true to life. Looking at a print under artificial tungsten lights makes it appear warmer than it is; under fluorescent or low-energy bulbs, it may look green. It's often best to let the print dry for several minutes before evaluating, as inks may change colour and density as they dry.

Printing without a computer

There are several routes you can go down to make prints without a computer. However, for serious image manipulation you still need a computer

PictBridge

Cameras and printers now use a universal system, PictBridge, that allows them to communicate directly without the need for a computer: you simply plug the camera into a printer, via a USB cable, and print. Some printers also allow you to place the media card into a slot and print from this as well. Although this is a good way to create instant prints on location, there are few options for improving the quality of the print, and you will find yourself limited to simple tasks such as brightening or cropping. Many new inkjet printers are now PictBridge-compliant.

Photo labs

You don't have to buy a printer, as you can take the digital images down to your local photo lab, which is geared up to produce prints direct from digital media. You can take the original memory card to them or manipulate the images first and put them on a CD, DVD or Zip disk. The lab will then print the images on traditional silver-halide photo paper.

A growing number of labs offer an Internet service. You simply e-mail the images to them, and they print and return the finished photos by post. Most labs can specify the required resolution, and you can also download their software to allow you to send images directly to them. This is a good way to get traditional photographic prints if you have a fast broadband Internet connection, and the print quality is very good; however, as with film exposures, if you do not get the shots right in-camera, the results may be disappointing; make sure you correct the images first for best results.

Dye sublimation printers

Dye sub printers offer excellent quality similar to silver halide prints, with no dots visible, and have come down in price over recent years. Most offer small print sizes of 6x4in, but one or two models can produce 10x8in prints. The system works by passing a sheet of paper through the printer three times, printing cyan, magenta and yellow on successive passes. A protective coating is then applied. Each pixel is faithfully reproduced as a square of colour, so resolution needs to be only 250ppi to maintain photo-quality results.

Dye subs produce more subtle prints than an inkjet, as there is no black to beef the image up, but if you can afford one they are capable of great results. New models using the PictBridge system are very portable and can be used as an instant mini-proofer when working or visiting friends; other models still require a computer to process the prints. The average cost of a print is higher than for an inkjet print.

Print resolution

It can be confusing when printer manufacturers talk about a resolution of 5760dpi, yet you only need to print an image at 300ppi. One pixel is made up of several large dots, which in turn are made up from many microscopic inkjet dots.

Dpi and ppi

The term dpi, or dots per inch, is a hangover from traditional reprographic printing, where screens used for printing were actually made up of tiny dots almost invisible to the human eye. If you put small enough dots together, the eye perceives them as a continuous tone image.

A digital image is made up of square pixels, not round dots, so the term ppi, or pixels per inch, is normally used. The numbers are similar, so think of dpi and ppi as essentially the same thing. Whether dots or pixels, 240–400 of them per square inch (6.45sq cm) creates an image we perceive as continuous tone. Due to the different methods of printing, this is usually 240–300ppi for dye sub printers (which actually print each pixel faithfully) or silver halide prints, and 300–400ppi for inkjet printers. The higher figure is preferable if using type within a print design

▲ *Invisible dots*
At this size the human eye cannot see the tiny dots of ink so they look like a continuous tone image.

or for images that are intended for use in a magazine or book. These figures apply no matter what size of print you create, so the bigger the print, the bigger the file size becomes. If you print using a smaller number of pixels per inch than recommended, your image resolution or detail will suffer and the result will be an effect called pixellation, in which you can see the actual individual pixels.

Inkjet printers use tiny dots of ink, smaller in diameter than a human hair, to create an image, and if you were to enlarge if sufficiently you would see that each pixel uses hundreds of dots, hence the large 5760dpi figure. This is where the confusion often arises about resolution: it is easier to think of dpi as microscopic droplets per inch, not dots per inch, where 10–20 such droplets are needed to make one dot visible to the naked eye. In theory the more droplets per inch the better, but in practice there is a cut-off point where you won't notice any improvement in quality and are just wasting lots of expensive ink for little gain. As with any product, always do lots of research and check out comparison tests in magazines before purchasing a printer.

▲ *On closer inspection*
Zoom in closer and you begin to see a few dots. The offset printing of each ink colour creates a rosette pattern so different inks don't overlap and become a muddy black.

Duotones

Duotones are the subtle combination of two colours: these are usually black and one other, but you can combine two other colours, such as blue and green.

The range of duotones

The use of black as one colour allows you to maintain good detail and contrast in the image. Photoshop allows you to recreate a traditional duotone effect easily, and you can also go one step further and create tritones and quadtones, using three and four ink colours respectively.

The duotone process increases the tonal range of grayscale mode images and makes images print better when in this mode, and it is an interesting alternative to colorizing the image using the Hue/Saturation command.

Some duotones use black and grey ink where the black prints shadows and the grey is used for midtones and highlights. In other cases, the black is used for shadows to maintain contrast and the colour is used to create some midtones and mainly highlights. Specialist ink companies such as Lyson and Permajet use special 'small gamut' ink sets made up of just greys and blacks, or from a limited colour range, to create smooth graduations and accurate black-and-white or toned prints that emulate duotones.

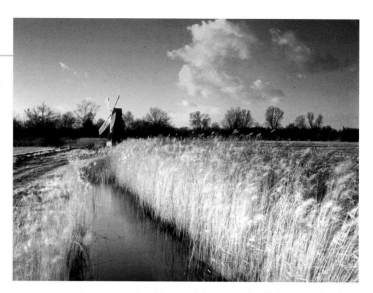

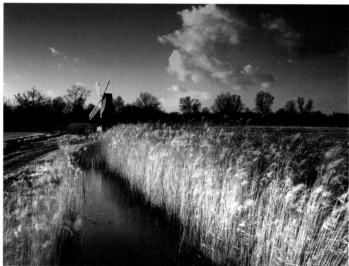

▲ **Before and after**
Compare the original image with the result of using the duotone command. The colour permutations are almost limitless, but care should be taken to use colours that work together.

Step 1 ▶
The image must be changed to grayscale using Image > Mode > Grayscale before using Image > Mode > Duotone to create a duotone. A dialogue box called Duotone Options appears. Select Duotone in the Type drop-down menu (or Tritone/Quadtone if required) and then double-click the white box in Ink 2.

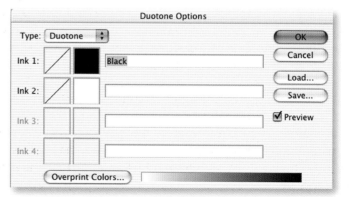

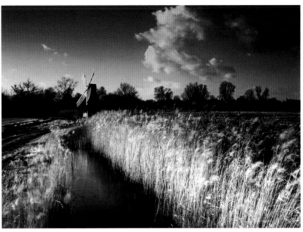

▲ Step 2

A second box called Custom Colors appears, from which you choose a colour. There are many choices of colour groups in the Book menu, all of which work in the same way. Pantone® solid to process coated was chosen here and Pantone 1235 PC was selected to create a sepia effect. The chosen colour is put into the Duotones Options box. Click OK to complete the process.

Duotones allow high-quality prints to be made using the standard four-colour process on your inkjet printer. The results are rich in colour and tone.

▲ Using extra colours
This example uses a blue colour called Pantone 279C.

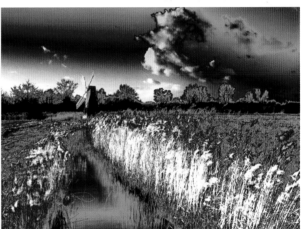

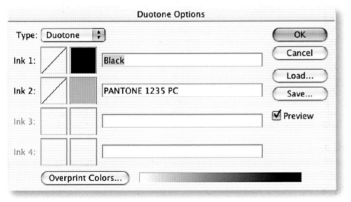

▲ Step 3

To the left of each colour that you have used in the Duotone Options box can be found the Curves dialogue box. Click this to open, and you can then make changes to the Curve for each individual channel.

If you want to affect global changes – changes that affect the colour or tone across the entire image – it is better to use the standard command of Image > Adjustments > Curves, as this will give you more control; however, you can also make changes to the entire image using the standard Levels command.

▲ Alternative treatment
Use Curves to create some interesting solarized effects. The limited palette of colours allows a better effect to be achieved than in the RGB mode.

Trade Tip
📖 By clicking on the Load button you can access the extensive range of sample curve settings found in the Presets folder in Photoshop. These are split into three main subfolders: Gray/Black, Pantone and Process Duotones. Use these as a starting point from which you can experiment and create your own presets. These can be saved so you can create your own folder of combinations. This system uses exactly the same principle as the presets of other tools.

Printing troubleshooting

correct

red

yellow

Hopefully you won't find that have too many problems when printing your latest images; apart from any technical problems, the colour of your photographs is likely to rate as your major concern, so here are some suggestions that are designed to help you correct any problems you might encounter along the way.

Understanding colour corrections

You can alter print colours using the Color Variations or Color Balance dialogue boxes in Elements/Photoshop or the custom colour controls in the printer software.

Colour correction If a print is:

too cyan ▶ increase red/reduce cyan or increase magenta and yellow

too yellow ▶ increase blue/reduce yellow or increase cyan and magenta

too magenta ▶ increase green/reduce magenta or increase cyan and yellow

too green ▶ increase magenta/increase magenta or reduce cyan and yellow

too blue ▶ increase yellow/increase yellow or reduce cyan and magenta

too red ▶ increase cyan/increase cyan or reduce magenta and yellow

◀ **Correcting colour casts on prints**
The photos here and on the opposite page show the correct image and the colour casts you may come up against when creating prints. Only by seeing what the problem is with the print will you be able to start making corrections.

magenta

green

blue

cyan

Other common problems

Problem: Print changes colour partway through.
Reason: One or more ink tanks have run out during printing. Check the Utilities panel to find out which ink tanks need replacing.

Problem: Colours are dull or bleeding.
Reason: You have printed on the non-printing side of the paper. Check the paper carefully before printing. You have specified a photo-quality paper setting but used a cheaper paper that cannot hold the ink.

Problem: Lines appear in the print.
Reason: The nozzles in the print heads are dirty. Use the Utility dialogue box to clean the heads.

Problem: Quality is poor or not as expected.
Reason: Check that you have used the right paper and the right print setting: you may have selected economy instead of quality. Use the manufacturer's own ink brand if you have installed third-party inks.

Problem: Printer produces a garbled mess.
Reason: There is probably not enough RAM available. Quit all unused applications, assign more memory if applicable, print a smaller file or increase RAM by purchasing a new memory module. Printing an image with many layers uses up a lot of memory. Flatten the image down, remembering to save a layered version.

155

Alternative printing options

Most people are happy with a small print that they can frame or put in a photo album, but digital printing has created other interesting and creative ways to present printed images.

Canvas prints

You can have an image printed on to paper or canvas and stretched over a frame to look and feel like a traditional painting. High-tech printers can print to very large sizes, and the final effect looks stunning.

Ceramic tiles

If you want to create a unique design for your kitchen or bathroom, you can have a photograph turned into ceramic tiles. This is relatively expensive but suits small designs.

Worktops and sinks

A product from DuPont called Corian allows a photograph to be fused into resin and used on countertops or sinks. The effect is extremely durable, so if you fancy washing your plates in a field of sunflowers, this is for you!

Photos on glass

Laser technology can now be used to engrave glass with a photographic image. The laser focuses its beam inside the glass and creates fractures within it to produce the final image, which seems to float inside the glass.

Photos on furniture

Have your favourite shots put on to a lampshade, chest of drawers, cushions or blinds, or even a shower curtain. Other ideas include having a picture printed on to a mug, plate, mouse mat, bag, keyring or wallet. Look out for transfer paper, which you can buy from good computer outlets. This prints just like a normal inkjet print, and you can then iron an image on to a T-shirt.

Fabric designs

Some companies will print your own image on to fabric, so you can have curtains, wallpaper or sofas with images on them.

Create your own place mats

This simple idea allows you to create your own tablemats. The first step is to buy some plain tablemats and coasters that you can place your own images on.

Next, print out several images to the size of the mats. To trim them to exactly the right size, try turning the prints over, placing the mat on top and tracing around the edge with a waterproof pen. Cut inside the line so the print doesn't overlap the edge of the mat. Now glue the prints on to the surface of the mats. Use a strong glue to bond each print to a tablemat, and place a weight on top if necessary to keep it flat.

Leave to dry and then paint the top surface with several coats of polyurethane clear varnish to waterproof the print; this should give the mats a long-lasting finish. Try creating a theme to your designs, such as the four seasons, flowers or landscapes, for a more unified effect.

A simpler idea is to have some prints laminated at your local office supply shop, making instant waterproof mats. This can be fun for children to do.

▲ *Place mats*
If you can create and fix your own designs, you need never run short of interesting and eyecatching gifts.

Index